ONE FAMILY

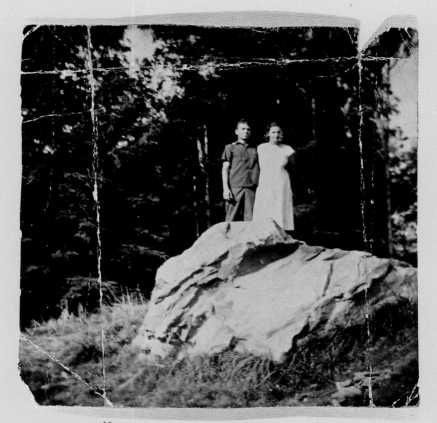

JOEL AND LOIS ○ 1966

ONE FAMILY

BY VAUGHN SILLS

Foreword by Robert Coles
With poems by Tina Toole Truelove

THE UNIVERSITY OF GEORGIA PRESS

ATHENS AND LONDON

PUBLISHED BY THE UNIVERSITY OF GEORGIA PRESS

ATHENS, GEORGIA 30602

PHOTOS AND TEXT © 2001 BY VAUGHN SILLS

FOREWORD © 2001 BY UNIVERSITY OF GEORGIA PRESS

POEMS BY TINA TOOLE TRUELOVE © 2001 BY TINA TOOLE TRUELOVE

POEM BY JOE TOOLE © 2001 BY JOE TOOLE

ALL RIGHTS RESERVED

DESIGNED BY KYONG CHOE, KYONG CHOE DESIGN, CAMBRIDGE, MASSACHUSETTS

SET IN FF SCALA AND FF SCALA SANS BY KYONG CHOE DESIGN

PRINTED AND BOUND BY C&C OFFSET

THE PAPER IN THIS BOOK MEETS THE GUIDELINES FOR PERMANENCE AND DURABILITY

OF THE COMMITTEE ON PRODUCTION GUIDELINES FOR BOOK LONGEVITY OF

THE COUNCIL ON LIBRARY RESOURCES.

PRINTED IN HONG KONG

05 04 03 02 01 C 5 4 3 2 1

LIBRARY OF CONGRESS CATALOGING-IN-PUBLICATION DATA

SILLS, VAUGHN, 1946–

ONE FAMILY / BY VAUGHN SILLS ; WITH POEMS BY TINA TOOLE TRUELOVE.

 P. CM.

ISBN 0-8203-2199-0 (ALK. PAPER)

1. PHOTOGRAPHY OF FAMILIES. 2. TOOLE FAMILY—PORTRAITS. 3. RURAL

FAMILIES—GEORGIA—ATHENS—PICTORIAL WORKS. 4. FAMILY—GEORGIA—

ATHENS—FOLKLORE. 5. SILLS, VAUGHN, 1946– —PHOTOGRAPH COLLECTIONS.

I. TRUELOVE, TINA TOOLE, 1969– II. TITLE.

TR681.F28 S54 2001

779'.2'092—DC21 99-053096

BRITISH LIBRARY CATALOGING-IN-PUBLICATION DATA AVAILABLE

●

TO THE TOOLES
 and TO MY FAMILY,

 MY SONS MATTHEW AND DYLAN
 MY MOTHER, MY SISTER
 MY STEPSON MATTHEW
 MY FATHER, WHO GAVE ME MY FIRST CAMERA
 and
 TO LOWRY

●

F o r e w o r d

BY ROBERT COLES

When the writer and physician William Carlos Williams went about his medical rounds on home visits (rather than hospital wards) he did so in certain neighborhoods in Paterson, New Jersey, an industrial city he came to know very well in the middle years of his busy doctoring life. In the evenings he would try to make sense of what he'd seen, heard; and, as a consequence, some of us, lucky to know him, learned a good deal as he remembered moments spent with particular children—his pediatric patients—and their parents. Once, after accompanying him as he did his work with his stethoscope, his blood-pressure kit, the instruments that enabled him to peer in the eyes and ears of the young and, inevitably, hold down their tongues as he took the measure of their throats, I heard him say this: "All day I'm trying to find out what's going on—in one home after another. I'm a hard-scrabble watcher and listener, I sometimes think. The poor folks I have as my patients, they don't make much, and I'm not much good at taking much from them, but I'll say this, I'm given a lot all the time: 'food for thought' as you hear people say! I'll sit at my desk and in my head there's one family, then another one, and I try to get hold of what's important that I've been taught by them—that I can try to put together for others who care to know, who want to pay attention to what I've written."

So it goes, and so I remembered as I read the pages that follow, whose heart and soul, in a way, Dr. Williams addressed with those words just quoted. He was, by indirection, telling an interested medical student about an essential principle of documentary work: A person such as this book's author arrives at a particular human scene in order to find out what is happening there. The person is a doctor taking pulses, scanning pupils, ear drums, or a photographer, or a writer, or a student, a scholar. The person observes closely, constantly, what is really going on, and, yes, interprets what is going on—and, finally, decides what to tell others, with which emphasis, point of view, lines of argument. Needless to say, Dr. Williams was not a self-conscious documentarian, but he was certainly attentive to those he treated in Paterson (and elsewhere); he was keen to keep his own interests, his worries and aspirations, in mind as he asked his questions, put them with hesitation or insistence to others, to youngsters or to their parents or relatives or friends. The point, he knew, and often declared, was to do justice to the audible, the visual—and thereby lose enough of oneself in order to put oneself at the service of others, so that one becomes the accurate, responsive (and responsible) teller of their respective tales, their collective story as it has been lived in a certain place, at a certain time.

In that regard, this book would surely have interested him; he loved looking at documentary photographs, well understood the human truths thereby offered. He insisted, though, that the observer who attends others then presents a camera's pictures of them (or the picture that words artfully and invitingly enable) has to be, at times, the observer who has not only come near but has kept a certain necessary distance, lest a pertinent perspective be lost amidst a flood of details that drown both a given subject matter and the report of it which gets called a documentary—one rendered through pictures and words, but one in need of the coherence of an artist who knows how to trim, to exclude as well as include.

Such an approach is not unlike that of an artist as he or she works on a canvas, and this book is ours because its author, Vaughn Sills, who teaches photography in a northern college, took with her a sensibility very much like that to be found evident in the topic she teaches—images as they reflect choices made, preferences and purposes, ideas and ideals, all exerting their pull and sway over certain gifted individuals. True, photographers are enabled by a mechanical process, but cameras are held and aimed by men and women who pick people, places, angles of vision, and who engage with others in their own manner, notice things that matter to them, and, later on, amidst all the snapshots and fancy, large "stills," make decisions with regard to what ought be shown, in which sequence, and with respect to which aspect of all that has been rescued (or seized some would have it!) from an ongoing reality.

No wonder, then, Dr. Williams referred to himself as he made mention of the others whose situation, even fate, he wanted to describe. No wonder, as well, James Agee in Alabama (not all that far from the Bogart, Georgia, of the pages that follow) gave us so much of himself. Indeed, his personal story, his antecedents and experiences truly gave shape to what he noted and then turned into the soaring, idiosyncratic lyric that is *Let Us Now Praise Famous Men,* as did George Orwell's introspective asides and opinions in *The Road to Wigan Pier;* tenant farmers in the former, miners in the latter, are, finally, handed us through the ones who betook themselves to those ultimately portrayed on the pages of books we now make our own to consider. So, too, with this book; here "one family" becomes a group of fellow human beings for us grateful readers to meet and get to know—even as we learn, right off, from a photographer and a writer and a teacher, who she is, how she came to be interested in a part of the world known as the American South, and how, also, she went about her self-appointed task and got to do it with such arresting, convincing success.

One Family, as a consequence, becomes a biologically connected arc of humanity deeply and knowingly explored—its ups and downs, its breakthrough moments and setbacks, and not the least, its distinct possibilities, its everyday lyrical and melancholy sides, all worked into a documentary volume well worth inclusion in a broad range of classroom discussions, reading lists. The Tina of *One Family* gives us the poetry of everyday life, of towns across the nation as well as of Georgia's Bogart—even as those who turn words into songs, the once seen or imagined into a palette's permanence, or that of a book such as this, become our eye-opening guides, our wonderfully suggestive instructors.

After twenty years of visiting with the Tooles, of photographing them, of being allowed into their lives in a way no one could ever expect, I am indebted to each of them for their acceptance of me and their willingness to share so much of themselves—with me, and now with you.

I thank Lois and Joel, whose spirits, though surely troubled and burdened, were undeniably strong and loving.

I thank Tina, whose intelligence and strength and capacity to love and to be a good mother are evident in her face and in her poetry.

I thank Joe, whose reserve and hard-working ethic often mask the gentleness I see when he holds his daughters.

I thank Lynn, whose silence disappeared the moment her first child was born. Her tenacity and strength are clear to all around her.

I thank Alice for her thoughtful explorations and willingness to share her understanding. Her introspective nature makes her at the same time vulnerable and strong.

I thank Mary, whose heart is sensitive, whose mind is insightful, and whose words are eloquent.

I thank Mickey for his straightforwardness and for his humor.

I thank Jerry for being forthright and generous. Jerry was articulate and sophisticated as he asked me the hard questions I have asked myself so many times; he challenged me to be clear and honest about my perceptions of his family. And ultimately he trusted me.

All of Lois and Joel's children have married and had children. I have gratefully photographed the grandchildren—Chris, Justin, Michael, Melodie, Angela, Nichole, Courteney, Ashlynn, Tasha, Leigha, Jessie, and Lisa. And now the fourth generation has begun; Angela's children, Chellsey, Christin, and Jonathon, also appear on these pages.

Husbands and wives and boyfriends and girlfriends—Donald, Beth, John, Thomas, Brenda (although my photographs of her were taken too late to be included here), Suszan, Shane, Mike, David, Kerry and her father Frank—are or have been very much a part of the Toole family, and I am indebted to them for participating in these photographs. One granddaughter has asked to be unnamed here; I respect her wish and thank her for allowing me to use her pictures.

All of these people have allowed me to make these pictures and this book; like Jerry, most of them have asked me questions and expressed understandable concern about my purpose, my goal, and my sense of the family. Many went with me to see an exhibit of the work represented here at the Atlanta Photography Gallery, and almost everyone reviewed and critiqued the manuscript. I appreciate beyond words each person's willingness and trust; I hope that this book is, and that I am, deserving of that trust.

All have allowed me to be touched—and changed—by their lives. I thank the Tooles for all that they have given me, for what I believe is their truth. And I hope and feel that, though clearly sifted through my understanding, what emerges here is not dissimilar from their truth.

Sara Glickman was my constant companion throughout this project. Each night she listened to my stories of the people I had seen and talked with and photographed, of what I felt and thought and learned, and together we asked Why? over and over again. Her questions helped me learn what more to look for, what else I might think about. Sara was also my first reader and editor; she pored over hundreds of pages of transcripts and selected and edited the passages that she thought were most important. Sara's perceptions—caring, insightful, and respectful—about which parts of the text to use, about what mattered, were unerring and have provided guidance throughout this endeavor.

Lowry Pei has helped me in several ways in creating this book. He, too, read over the transcripts and poems, sometimes confirming choices Sara and I had made, sometimes finding other passages that he thought should be included. He edited the transcripts with an unwavering instinct for preserving the sound of the Tooles' language, the meaning of their words, the integrity of each person's voice. As I composed my own words and put together the images and text presented here, Lowry was my primary advisor, providing the wisdom of the novelist that he is. I thank my beloved husband for all of this—and more.

I am indebted to Kyong Choe, the designer and friend who elegantly transformed a concept and a wish into an actual book. I have had help from many others: Sarah Putnam looked at contact sheets and prints and gave advice when it was most needed. Douglas Perry offered me a thoughtful and extremely helpful response to my introduction, and his dissertation on James Agee's *Let Us Now Praise Famous Men* has given me a much

deeper understanding of that work. Lara Adler rephotographed and printed the pictures from my childhood photo album. Rachel Dow scanned most of the images into the computer, with goodwill and patience; she offered friendship, not to mention entertainment, even on our busiest days. Erica Sybertz, Tamara Kaldor, and Jodi Braham helped with production of the manuscript. Mark Guilmette and Rachel Faith printed many of the small prints needed for the scans and some of the large prints for exhibition. To all of these people I offer my gratitude.

Anita Peck transcribed hours of tape recordings. I am grateful for her knowledge of southern dialect and names and places and for her meticulous work. Although Anita never met any of the Tooles—and didn't see their pictures for years—she became captivated by their story and often asked me about how Tina was doing, or Jo-Jo, or Lois.

Through the power of their words, Anita grew to care about this family.

Throughout all of this, I have learned (anew) that I can be a bit trying—a perfectionist about my own work and frustrated by my own inadequacies; I sometimes get rather on edge. I thank all of these people for sticking with me, humoring me, and even, at the most unnerving of times, simply ignoring me.

Friends, family members, and colleagues have encouraged and supported me, critiqued my pictures, read and proofread this text, and listened to stories about the Tooles and our encounters. Included in this list are Maryjean Viano Crowe, John Crowe, Ellen Dockser, Carl Glickman, Katherine Jelly, Doris and Keith Jelly, Nancy Johnson, Debbie Kernochan, Estelle Jussim, Art Sills, Susan Sills, Judy Weinstock, and Peggy White. Bill Kates's belief in me and in my work was invaluable, but not so as much as his teaching me to believe in myself. Bob Oppenheim

created a particularly successful exhibit in 1987 in the Trustman Art Gallery at Simmons College that helped me to see my work in new ways. My children Matthew and Dylan didn't complain when, year after year, I spent a few weeks away, very often including Mother's Day; while I missed them during these times, I felt that they gave me a true gift: I was doing exactly what I wanted to be doing—making pictures of the Tooles.

Many more people, including my wonderful students, colleagues at Simmons College, friends—too many to name here—have been helpful; their response to my work and their interest in the Toole family have meant a great deal to me.

I am grateful to all of the people at the University of Georgia Press who have been involved with this book. The people who first saw the book—Malcolm Call, Erin Kirk New, and Sandy Hudson—responded to the underlying feelings and ideas that I hope to convey with such understanding and caring that I felt sure that the book had

found its home. The suggestions made by Malcolm Call always led to improvements. Kristine Blakeslee's many suggestions were gently delivered; she edited with a keen and attentive eye, as she consistently valued the voice and meaning of the speaker or writer. Sandy Hudson facilitated the design and production of the book with grace. Although I cannot name everyone here, I wish I could, for many have helped to make this experience an exciting one for me—and more importantly, to create a book that I believe will honor the lives portrayed here.

In addition, I would like to thank the Massachusetts Council on the Arts and Humanities, the Polaroid Foundation, and the Polaroid Corporation for grants that supported my photography and ultimately helped make this book possible.

Introduction

BY VAUGHN SILLS

For the past twenty years I have been photographing the Tooles. First by looking at them through the lens of my camera and later—slowly—by hearing their stories, I have learned a great deal about who these people are and how they have lived and survived. I have seen their love and their pain; I have looked intimately into the lives of these people for whom I have come to care deeply. Whatever semblance of objectivity I once had is now gone. I am no longer simply curious and inquiring; I am neither neutral nor omniscient. I am fully involved. For me this has become a labor of love.

As I write these words, it becomes impossible not to acknowledge, however inadequately, my affinity with the work of Walker Evans and James Agee. In *Let Us Now Praise Famous Men,* Evans created images that have become icons, impressing me even before I had studied them. Agee writes that photography has the ability "to perceive simply the cruel radiance of what is," suggesting that a photograph can go beyond artfulness, even beyond art, to something much deeper: if a picture is honestly made, and if one pays ever-so-close attention, this radiance reveals truth, which, as Keats has written, is beauty. Radiance suggests, too, something spiritual,

which makes sense, for Agee writes that his and Evans's work was "essentially an... inquiry into certain normal predicaments of human divinity." In my work with the Tooles, I have seen beauty, I have seen truth. And I have seen spirit—both human and divine—even though I was not on a mission to find this. I hardly knew what I was looking for; I found what I did not anticipate.

◉

Like the Tooles who are undoubtedly descended from the Irish (with a good amount of Cherokee ancestry, too), the paternal line of my family comes originally from Ireland; but my ancestors went to what is now Prince Edward Island and Nova Scotia and eventually married with the Scottish and then the English. Beginning their migration from Prince Edward Island, my parents moved first to northern Quebec where I was born, then to New Hampshire where I began school. The happiest parts of my childhood took place in and around our home there and when visiting my grandparents on Prince Edward Island, exploring the red sand bars and tide pools, playing croquet on the vast lawn and intense games of Scrabble and Flinch with my grandparents in their summer cottage.

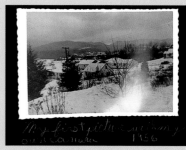

MY FIRST PICTURE ∘ 1956

I remember the years in New Hampshire as filled with great girlhood adventures. The house we lived in was different from the others in Berlin: my father had chosen land at the farthest end of town and at the top of a hill so steep I couldn't ride up it on my two-wheel bike; the house he designed and helped build was modest, but it had a contemporary flair with built-in bookshelves, a handsome fireplace, real art work (behind one painting that swung open on hinges was our discreetly placed first television set). From the front window of our house, I could see the streets at the bottom of the hill and, beyond them, the mountains of New Hampshire. Behind our house was a forest that I believed was endless, and I spent my time in my private room of the woods—in the dreamy world of colors, textures, and shapes of my secret hiding places under tall trees and of the far-off mountains—and in the busy and fabulous life at the bottom of the hill.

Life was most exciting on the weekends. My best friend Mary and I played fantasy-filled games in the woods behind my house, and we would ride our bikes up and down the streets of newly built, simple but comfortable houses. In my memory, when I was nine Mary slept at my house every Friday night and in bed we made up stories that were romantic and sexy: handsome young men desired us and touched us in ways that we imagined would evoke passion and love. Saturday mornings we walked into town, had the best salty French fries I've ever tasted and Cokes at Woolworth's, then went to our boyfriend Terry's house, where we chased him around his backyard until we caught him, pounced on him, and kissed him mercilessly, with all the fervent intent of young girls' passion. I never knew whether or not he liked it.

My other good friend in Berlin was Martha. Martha and I didn't spend the night together—ever, as far as I can remember. I saw her mostly at school. Martha's family was poor; they lived in a run-down house that had almost no yard and was crowded with sisters and brothers and an assortment of other relatives. I didn't feel comfortable in Martha's home, and I had the feeling that our friendship was somehow illicit. But why? Was I simply self-conscious about having more than she had? Did I feel guilty about this inequality? Or was it more than that? Something told me that I was crossing over a line that I wasn't supposed to, that I was looking into a world that I was not supposed to see. I was a girl-child in a world telling me to be nice. And this world still tells me that.

That same year, we took a family vacation that was quite different from our usual trek to Canada to visit my grandparents: this time we traveled through the eastern half of the United States, to and through the South, arriving in New Orleans after several days of steady driving. Under a sun that blessed our trip, our brand new '57 Ford convertible, with its white paint and glistening gold stripes, carried us in an aura of excitement and discovery. It was an extraordinary experience for a kid who had known only the mill town of Berlin, the shore of Prince Edward Island, and the small Baptist home of my grandparents in Nova Scotia, but at first I didn't recognize that. Driving away from home, I was initially absorbed in books; I read *Anne of Green Gables*, probably a Nancy Drew mystery, and the biographies

UNTITLED ∘ 1957

of famous women such as Amelia Earheart and Clara Barton. I was, of course, trying to figure out how people, women especially, lived their lives.

But when we crossed into the South, far from home and what I was familiar with, I noticed more of what was happening outside the car. My first camera was a plastic Kodak Brownie, and among the earliest pictures that I took—or at least valued enough to save in an album—were those from this trip. Through the car window I photographed small wooden houses—they looked like shacks to me—sitting in large open fields, with only a few shade trees around to relieve the flatness of the land and the heat of the sun. I tried to imagine what it would be like to live in one of these forlorn and insubstantial-looking places. Would it be like living Martha's life? These houses looked even smaller, shabbier, and more isolated than Martha's. I assumed that the families living in them were black; certainly they were poor. The heat and light were different than in the North. Did that make a difference to the people inside? All I knew for certain was that the books I had been reading didn't answer my questions about the people in those little unpainted houses in the hot, wide-open fields.

A year or so after that first visit, my parents continued their migration, moving to Baton Rouge (eventually we would return to Prince Edward Island, my parents to retire, and I to spend my summers). For the first two months in Baton Rouge we lived at the Belmont Motor Inn. My younger sister Kathy and I were thrilled by the swimming pool, the restaurant food, and the staff, who took a liking to us. Soon we began to attend the nearest school and my world suddenly changed. In school I was a suspect character: a Yankee. I was different. My

clothes—plain dresses or plaid skirts, blouses that nearly always came untucked, and practical tie-up shoes—weren't right; my words sounded peculiar and were even corrected by my teacher. I quickly adopted the ways of my new peers, hoping, of course, that this would help me find new friends. I began to wear starchy petticoats that made my skirts stand out from my skinny legs, pretty dresses in candy colors, and slipper-like flats; I learned to play tether-ball; I learned to say "yes, ma'am," and "no, sir"; eventually, I even learned to flirt.

When we moved into our new house in the Villa del Rey subdivision, Kathy and I started another school; there the petticoats weren't so flamboyant, the game of choice was kickball, and the playground was covered with grass, rather than dirt. Again I observed and made quick adjustments. The distinctions between classes were subtle but not so subtle that a ten-year-old didn't sense them. I did not see poverty or African Americans in my new neighborhood or in my school. But on exploratory drives with my father through other neighborhoods and when picking up the woman who sometimes helped my mother with cleaning and ironing, I did see glimpses of a different kind of life.

In Baton Rouge there was no Martha in my life; she would have been inaccessible to me. I soon learned that poor white people—especially if their roots were in the country—were called "white trash" and that economic segregation insulated me from people with very little money, just as racism separated me from blacks. I found that I saw some things differently than my new friends.

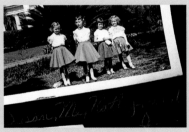

UNTITLED ° 1957

The war that I thought had ended nearly a hundred years before was still alive to them—the issues were still present, the old wounds still raw. I thought that schools should be integrated and argued about this in the classroom, on the school bus, and at slumber parties. My tenth-grade civics teacher referred to me as a "nigger lover," I was derisively dubbed "Yankee" by the boys in my class, and later, on a college trip through the South, old friends called me an "outside agitator." Living in Louisiana in the late fifties and early sixties and then returning to the Northeast to attend college, I focused my most ardent political thoughts on civil rights.

I began to understand something more about my relationship with Martha: I was supposed to think that there was something wrong, indeed something disgraceful, about being poor. It seems to me now that I heard an implicit message that if poor people, whether black or white, would only try harder they could make it, that they were lazy, alcoholic, or simply not smart. Thus, my friendship with Martha was somehow tainted, unworthy, perhaps even shameful.

◉

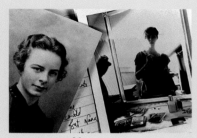

BUT NANA ◦ 1986

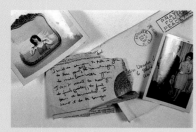

PRAY FOR PEACE ◦ 1983

About twenty years after that first drive south, I returned for a second time. Although I was not conscious of it then, I realize now that when I went to Georgia in 1979, it was with a purpose: I would get out of the car and, using my camera as a divining rod, I would try to find out what life in a small house that sat in a hot field was like. I remembered what I had seen and felt on that first drive through the South when I was nine, and I remembered, too, what I knew I hadn't understood then.

By this time I had declared myself a photographer. My pictures were mostly of people and often included the places where they lived, which I feel can be as revealing as a face. Drawn to the beauty of the unselfconscious world of nature and of the seemingly ordinary, I took my camera wherever I went. In early 1978, while on a family vacation in St. Martin, I had driven the single road that circled the island, looking for pictures. I found them at a few stops along the way—a wispy tree in a field of windblown grass and glittery light, a small storefront building colorfully painted, a few kids playing on the side of the road. These children took me to their home, up a little dirt road, where I began making pictures in earnest— first of them, and, soon, of their mother, a grandfather, an older sister who was pregnant, and a brother who seemed retarded. These pictures were about individuals as separate people but also about who they were within their family. I began to feel that the single image often didn't tell me enough of the what-is, that I needed more than one photograph to tell a story. I realized that by making a series of portraits of one person or a family, I saw more of the nuance and complexity of the self. Later, after I had begun taking pictures of the Tooles, I made a series of self-portraits that are about who I am as a woman and how I am shaped in part by who my mother is and who my mother's mother was and by my relationship to both of them. In another series, I made daily portraits of each person in my immediate family—one picture a day, every day for almost a year, of my two teenage sons, my husband, and myself. My interest in families has taken me both outside and inside myself.

But before those projects began, in 1979, with camera and film and tripod, I flew to Athens, Georgia, to find another subject. It was like going home—perhaps not to a home I've known in this lifetime, but one that felt right. The colors of the soft red clay and the early evening light on the pine trees, the mist that lay over the fields welcomed me. In the South I feel an easy warm connection between body and earth that makes spirit more accessible. There is a sweetness, a softness in the air that entices me. The scent of pine needles, the heat from the earth as well as from the light of the sun warms and surrounds me; the sounds of crickets and frogs and birds are both more intense and more muted than in the crisper air of New England. The physical sense of self and of the earth seem more connected; here there are fewer barriers—the cold does not insist that I wrap my body and my feelings in layers of wool and protection. Life moves out onto front porches. Pleasure seems less restrained. The warm air draws out the emotions. When I arrived in the countryside of Georgia, this place did not call me a stranger. Perhaps my teenage years in Louisiana gave me a sense of belonging. And my dear friends Sara and Carl Glickman and their daughters greeted me with love. I was truly in my other home.

◉

On a chilly gray Friday in November, Sara and I took off in her pickup truck; we drove through a number of neighborhoods, looking for a place that would call to me. We followed a road that led us out of town, curving around and up and down low hills, passing stands of trees, a few businesses, a neatly tended trailer park, crossing a set of railroad tracks, before coming to a settlement of about twenty small wooden houses scattered along either side of the road, separated by stretches of trees, yards, an occasional small store or road sign. The houses were of similar design: square with pitched roofs, with two front doors, side-by-side; every house had a front porch extending nearly its whole width and facing the road. Most of the porches were filled with furniture: metal chairs, wooden rockers, sometimes an old sofa or a glider; there were tables, lots of potted plants, and other odds and ends that made each porch seem like an outdoor living room. If this had been a nicer day, folks would have been outside, sitting on their porches, sipping iced tea, watching whatever was to be seen.

The people who lived in these houses seemed to belong here: the furniture, plants, and toys on the porches and in the yards indicated that they had been here a long time; people of all ages, older people and families with children clearly lived here. Most of the homes and yards—whether of grass or, equally acceptable, swept dirt—were carefully tended, but enough material objects were visible to reveal character. Cars and pickup trucks sat in various states of disrepair and dismemberment, not to be towed off to a salvage yard but to be worked on or saved for useful parts or sometimes simply for sentimental reasons. I learned later that these houses had been built for mill workers, but many of the people who lived there in 1979 were either descendants of tenant farmers or had themselves been tenant farmers years before.

We slowed down, looking with interest at these houses and the few people we saw—a couple of older people working outside in their yards and one or two kids riding bikes. Our truck grumbled along the winding road, up and down the hills. Just near the crest of one, in a front yard of dirt and weeds, a small group of kids were playing. I knew we had come to the right place. I asked Sara to stop. I gathered my courage, pulled out all of my equipment, and, with little conversation, began to take pictures. Sara agreed to come back in a few hours, and I waved good-bye.

Tina and Joe, who, I would soon find out, were nine and seven, were playing with two little boys who lived next door to them. When their mother asked me not to take pictures of her sons, the boys left. At that point, Tina and Joe's mother, Lois, came out and joined us in the picture-making. On that first day we stayed outside the house, photographing in the front, back, and side yards. The Tooles were clearly as curious about me as I was about them. Joe and Tina stayed close to me, inspecting my camera and film bag, watching my moves. Inquisitive, like most kids, they asked about loading and unloading film, about the light meter, and about the development of film and pictures; they wanted to—and frequently did—look through the viewfinder to see what I was seeing, to see each other. Of course, Lois and the kids asked me why I was making these pictures; I said that I was interested in taking pictures of people, of families, including my own, that I was taking a course in photography, and that my work had been shown in a few exhibits. I wasn't expecting to publish the pictures I was taking, and I certainly did not imagine selling them.

I was asking questions, too, though probably fewer than they; I tend to be fairly quiet while I'm photographing. I muttered things like "Mmm, that's nice," and "You look wonderful, Tina," and "Where else should we try?" I did find out a little—how old the kids were, where they went to school, that the puppies were about eight weeks old, and to whom each dog belonged (there were lots of them, mangy and scrawny, and very much a part of the family). Perhaps oddly, I wasn't asking questions that might have helped me figure out what these people's lives were all about; I was simply seeing—looking at what was in front of me, all around me, making pictures out of what was here. I think that, for a while at least, I suspended judgment or evaluation; what was here was just this: three people—a mother, a daughter, a son, living together, affectionate and closely connected, in their home, surrounded by all their belongings, and, for some reason, looking at me and into my camera without masks or pretense or self-consciousness. Together we made pictures.

I am shy by nature, and photography is a strange vocation for a shy person. It requires intrusion, imposition—behaviors I'm not comfortable with, behaviors girls are warned against. However, I am intensely curious about people. There are things I want to know that are not easy to come by—the secrets of our inner lives, the how and why of what we feel; I want to know about others' loves and passions and disappointments, about what brings happiness and sadness; I want to know where others find solace. The camera has become for me a way of learning, a way of seeing and attempting to understand, and, in the end, my way of expressing what I feel, how I see this world. So on that day in November, Tina and Joe playing in their yard, Lois inside her house,

and my camera helping me get past my inhibitions, I got out of the car to ask the unreasonable, the impolite, the unfeminine. I had to make myself not be nice. I asked for a lot—for pictures, and for a certain acceptance and trust—but apparently I did not ask for too much; the Tooles were willing to allow me the time and the intrusion into their lives. I have wondered why. And I imagine that they accepted that I was not other than what I said: I was interested in taking pictures of a family, and they were that.

After I had photographed Lois and Tina and Joe for an hour or more, a school bus stopped in front of their house, dropping off a few kids, including Lynn, Tina and Joe's thirteen-year-old sister. Unlike her mother and her younger sister and brother, Lynn did not want me to take her picture. It can be pretty hard to be thirteen, and Lynn seemed to carry inside her a world of unhappiness; I didn't see in her face the light of hope and trust I saw in Tina and Joe. I answered her questions about what I was doing and why, but for a while she just observed us as we continued to make pictures. She hung around on the edges, while I watched and waited, wondering what would happen. I imagine that she didn't like feeling left out, and it was the puppies rather than my requests that eventually enabled her to become a part of the picture making. Tina and Joe thought the puppies should be photographed—as well they should—so they were held up to be part of the portraits; Lynn soon joined, holding a puppy herself, finally allowing me to take her picture.

The next day, Saturday, the weather was still cool and raw and gray. I returned to the Tooles' home, and this time we went inside. Even smaller than it looked from the outside, the house had three rooms: a front door opened into the living room; to the right, behind a closed door, was the only bedroom; just behind the living room was the kitchen, which, in turn, led to the back porch. It surprises me now that I didn't meet any other family members that day, but I did see pictures of them. Lois and Tina had pulled out a box full of framed family photographs to show me, so I learned about the four older sisters and brothers, none of whom were still living at home, and that there was a father who was very much a part of their lives. I stayed several hours, taking pictures and listening but learning little more than what was visually apparent. That, however, was quite enough to fill my mind and heart. Thinking that evening about what I had been seeing and hearing and feeling, I wanted to know more about the Tooles—the why of what I was seeing, the texture of their lives. But I was going home to Massachusetts the next day and would have to be satisfied by looking more closely at the photographs in the darkroom and on the walls of my workroom.

A year and a half later I went back to Athens to visit the Glickmans and to find another family to photograph. But when taking a stack of prints to the Tooles, it occurred to me that I might make more pictures of them. I arrived unannounced on a sunny Saturday afternoon and was in luck, for this time I met and also photographed Lois's husband Joel, Alice and her daughters, Mickey and his family, and Jerry. Although I don't remember this, Mary says she was there that weekend but wouldn't let me photograph her. I never attempted to look for another family—this was clearly the place to be.

On my next visit, I began to use a Polaroid camera and film because of the fine resolution in the negatives. However, another benefit was quickly apparent: the Tooles could see their pictures as I was taking them. The children clamored for the positives, while the adults claimed some for their family albums. And they participated even more in the making of these photographs, commenting on pictures I took, making suggestions, yet still willing to let me make the images in the ways that I wanted. The negatives are quite fragile, but the occasional scratch or odd smudge from my unorthodox processing and the quirky, evocative edges seemed to belong to the images, sometimes to portend the future or echo the past.

Spending hours at their homes each day for a week or so almost every year, photographing and listening, I picked up bits of the family story. Gradually I learned their history, but it would take me many years and many visits to feel that I knew anything, and even then most of what seemed like answers quickly became questions.

One warm September day in 1988 I arrived at the Tooles' new home at the end of a dirt road. (They had moved three times since I first met them, and sometimes it took some searching to find them.) In front of their house stood a big old oak tree, surrounded by a dirt yard on which a couple of pickup trucks and cars were parked. The house was flanked on both sides by two small bungalows that were originally railroad cars: in one lived Mary and her son, in the other, Lynn and her husband. Tied to the mailbox was a big pink bow, which, it turned out, announced the birth of a baby girl, Lynn and Donald's first child, the first baby to be born into the family since I had begun photographing them. The good news was balanced by sadness; Joel had died just a few months before from emphysema. But I also found out that Alice had been married just two weeks before, and Joe, now called Jo-Jo, and Kerry proudly showed me pictures of their wedding. Since Tina was seven months pregnant and didn't want to stay alone in her isolated mobile home, without a car or a phone, she was spending each day with her mother and sisters while the men went off to work. The family was especially close both physically and emotionally at this point; Mickey, Jerry, and Alice and their families gathered on the front porch in the evenings and on the weekends to coo over Lynn's baby and look forward to Tina's, to tell stories of their father, and to minister to Lois. By this point Lois was being treated for her "nerves" or "spells," diagnosed as manic-depression, but that fall she seemed to be overly medicated in an effort to relieve her extreme grief.

A few days later, I sat in Mary's kitchen, which had no stove, just an electric wok and a teakettle used for all of the cooking, and two refrigerators, one of which served as a cabinet. Her home was tidy and decorated with pictures, dried flower arrangements, and treasures obviously collected over time. Mary and I talked nearly the whole afternoon. I asked a few questions but for the most part I listened as she told me about her childhood, about her marriage and its breakup, and about what she knew of her parents' lives. We talked about her family—

about her son and about her sisters and brothers and their lives. I had learned the significant facts of the family history before, but Mary filled in many details and talked articulately about how it felt to grow up in her family. Once before, in 1981, I had tape recorded Lois and Tina talking about their lives, but, though the facts were given to me, a fullness, a depth was missing. And now, suddenly, unexpectedly, Mary was talking to me with openness and insight and deep feeling.

The next day, I bought a tape recorder at the local Radio Shack and, feeling sheepish and doubtful that my request would be granted, I asked if Mary would repeat some of the stories she had told me the day before and if I could record them. Amazingly she said yes; again we talked for hours, and again I was spellbound.

My goal then became to talk with all of the brothers and sisters and Lois, which I did within the next few months and have continued to do through the years. One person whom I very much wanted to hear from at that point was Tina—after all, I'd known her since she was a young girl and now she was married and expecting her first baby. So that I could take pictures of her in her own home, we planned an expedition: I would drive her to her trailer and use the opportunity to record our conversation. But I couldn't seem to help her relax. Oh, she told me everybody's birth date, how old her parents were when they married (he was nineteen; she, sixteen), and where they

had lived when—straightforward facts—but little that came from Tina's heart. When we got to her home, everything was perfectly clean and carefully arranged; family pictures (even some I had taken) dotted the walls and covered tabletops. But the light was dim, my pictures of Tina were disappointing (though I did get one of her living room that I was happy with), and our taped conversation, punctured with the sound of the shutter, was stilted and choppy. Fifteen minutes before we had to leave, Tina told me that she wrote poetry. Declining my suggestion that she read her poems aloud into the recorder, she let me take them home.

Reading phrases and verses in snatches while driving back to the Glickmans' house, I realized that Tina's words were compelling—her poems offered me even more than what I had hoped for in a conversation. Sitting with Sara in her living room that evening, I read the poems aloud; my throat filled with a scratchy lump, and when I glanced at Sara I saw her wiping away tears. The pain of disappointment, the damage caused by a difficult life, and the soul of a girl in need of love were poignant. In country music style, Tina had written true poetry.

On a recent visit I asked Tina about her writing: what got her started, had she shown her poems to others, where had the inspiration come from?—the usual questions writers are asked. She told me that she began writing when she was fourteen, after reading some pieces Lynn had written for a journalism class in school. Had she been encouraged by others, teachers perhaps? No, she told me, but she felt encouraged when she showed her

writing to me, by my caring so much about it, and about her. Over the years she has continued to show me her poems. I am delighted that Tina's poetry is a part of this book.

◉

In my search to understand something about the how and the why of the Tooles' lives, I have found answers to many of my questions, and much of what I've learned is offered here—in the poems that Tina has written and in her letters, in the words of the family, and in my photographs. But much is also left out. I've chosen not to include that which seems to me to be too personal, that which is truly private. It is not necessary to know every aspect of another's life to feel both the pain and the pleasure that exists within. The choices I have made have been augmented by the Tooles, who occasionally asked me not to record something that was about to be said or, later, to delete something from the manuscript. I hope that the reader will respect and honor the choices we have made.

Some questions remain unanswered because I chose not to ask them; others, because not all questions can be answered. As much as I would like to know everything about why people are the way they are, even about why I am the way I am, I have come to believe we cannot know everything. As I've learned this, I've also learned to respect the mystery of the individual, and to enjoy it. I hope you will find some of that mystery in these pictures—and in the spaces between the words and the images here.

My relationship with the Tooles has deepened and grown and become one that I care about a great deal. I have seen the children I photographed that first day grow up to have children of their own, and I have at last decided that though the portrait can never be truly complete, the time has come to bring together what I have photographed and what the family has shared with me. This book is the result of my trusting the tug of unexpected connection that I felt that first afternoon, and of the Tooles so generously trusting me.

It began under the flat light of a gray sky, in front of a simple home sheltered by a single tree, where two children played on a yard of dirt, grass and weeds. Their mother was inside, their sister perhaps just boarding the school bus that would bring her home; a small tan pickup truck approached and stopped, and I stepped out.

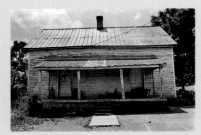

WHITEHALL ROAD ○ 1982

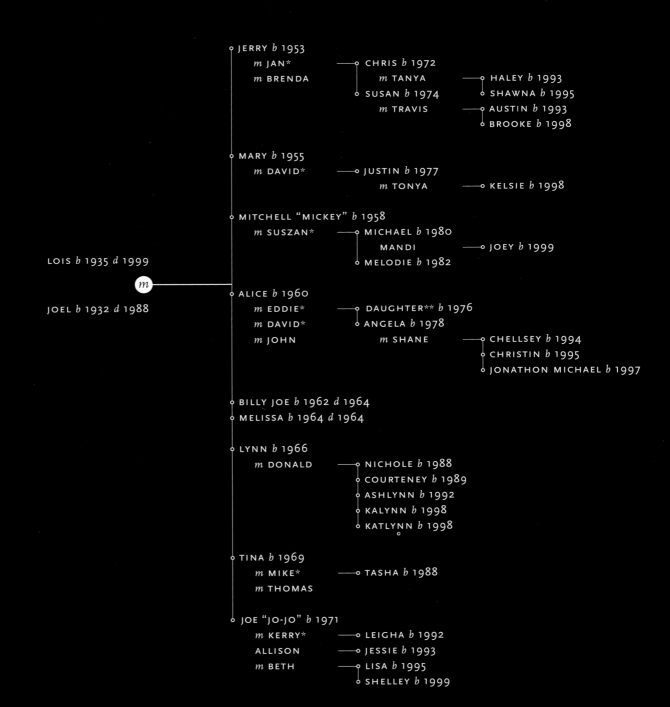

JERRY *b* 1953
 m JAN*
 m BRENDA
 CHRIS *b* 1972
 m TANYA
 SUSAN *b* 1974
 m TRAVIS
 HALEY *b* 1993
 SHAWNA *b* 1995
 AUSTIN *b* 1993
 BROOKE *b* 1998

MARY *b* 1955
 m DAVID*
 JUSTIN *b* 1977
 m TONYA
 KELSIE *b* 1998

MITCHELL "MICKEY" *b* 1958
 m SUSZAN*
 MICHAEL *b* 1980
 MANDI
 JOEY *b* 1999
 MELODIE *b* 1982

LOIS *b* 1935 *d* 1999

m

JOEL *b* 1932 *d* 1988

ALICE *b* 1960
 m EDDIE*
 m DAVID*
 m JOHN
 DAUGHTER** *b* 1976
 ANGELA *b* 1978
 m SHANE
 CHELLSEY *b* 1994
 CHRISTIN *b* 1995
 JONATHON MICHAEL *b* 1997

BILLY JOE *b* 1962 *d* 1964
MELISSA *b* 1964 *d* 1964

LYNN *b* 1966
 m DONALD
 NICHOLE *b* 1988
 COURTENEY *b* 1989
 ASHLYNN *b* 1992
 KALYNN *b* 1998
 KATLYNN *b* 1998

TINA *b* 1969
 m MIKE*
 m THOMAS
 TASHA *b* 1988

JOE "JO-JO" *b* 1971
 m KERRY*
 ALLISON
 m BETH
 LEIGHA *b* 1992
 JESSIE *b* 1993
 LISA *b* 1995
 SHELLEY *b* 1999

* DIVORCED
** ANONYMOUS
b BORN
m MARRIED
d DIED

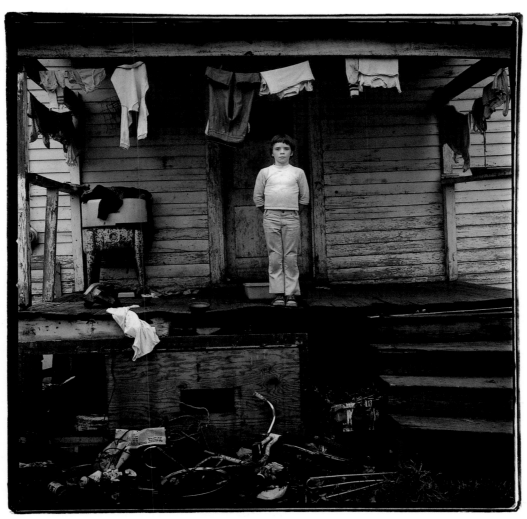

Joe ∘ 1979

I remember Mama used to take us to the store every Saturday. There was this little store down the road from where we lived at—it might've been a mile, probably not even a mile—and Daddy used to leave her money. Saturday morning we'd go to the store and buy stuff to make soup and sandwiches. Back then we ate beans and stuff like that all the time. We didn't eat sandwiches and junk food. That was the highlight of the day. We could walk to the store. —LYNN

Lynn ∘ 1979

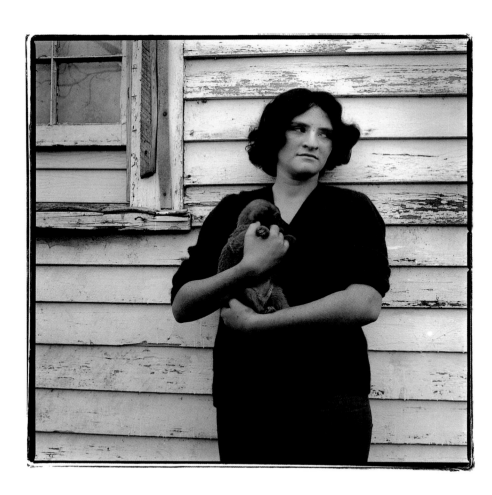

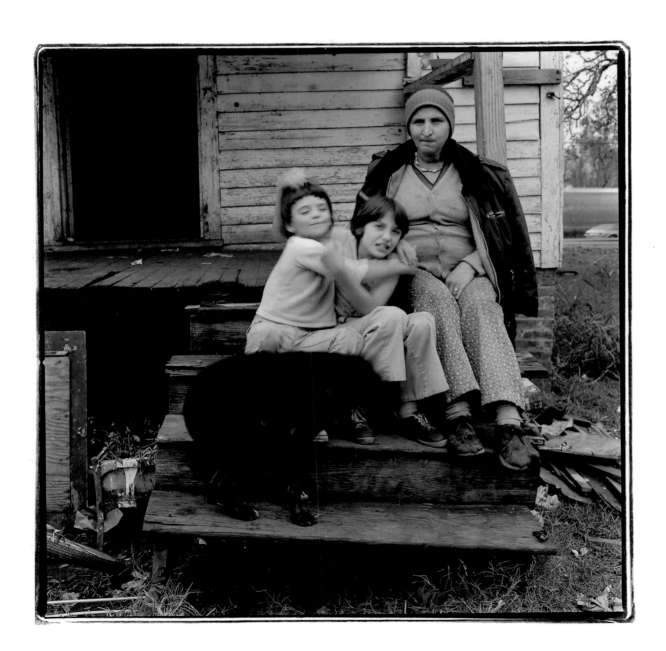

Joe, Tina, and Lois ∘ 1979

Tina and Lois ○ 1979

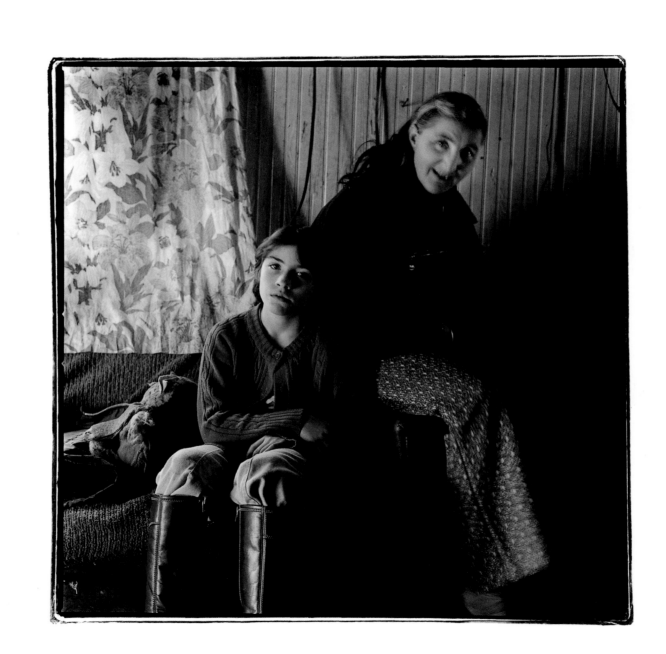

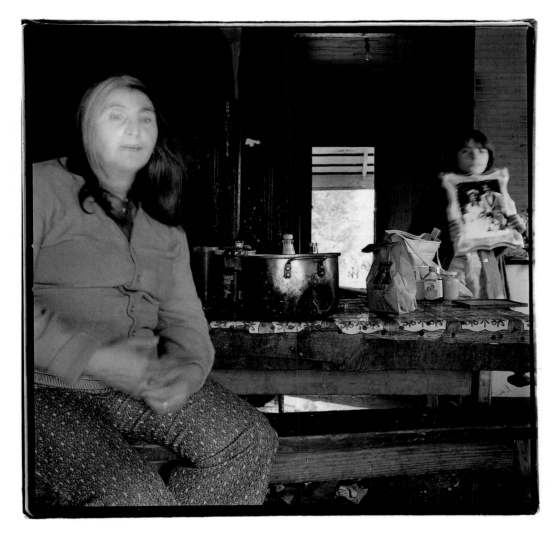

Lois and Tina ∘ 1979

Every September, October, it's time
to pick cotton, and we'd all get out
there and pick cotton to get money to
go to the fair. We'd go to town and
people'd be snickerin' behind our
backs and stuff like that. And people
at school wouldn't play with you
because you didn't have your—this
one girl at school used to make fun of
me when I was in the third grade
because Mama didn't iron my clothes.
I asked Daddy to please buy me a iron
so I could iron my clothes. Sue and
them's mama—now their older sister
ironed their clothes. They might've
been old clothes, but they were ironed
and ours weren't.

Mama had these two irons she put
on the wood heater to get 'em hot so
I'd try that, but most time I'd burn
holes in everything. Here I was a
little kid and burning holes in stuff.
—MARY

I don't remember being a little girl and playing with toys. I
remember being a little girl and babysitting and washing diapers
and washing dishes standing up in the chair to reach the sink.
And haul in water, bring in wood, wash clothes, and I don't
remember being a carefree little kid.

Some of it I do. We used to get in the woods,
me and Alice especially, and we'd pretend
we were Loretta Lynn. We'd pretend like we
was country singers. —MARY

Alice ○ 1981

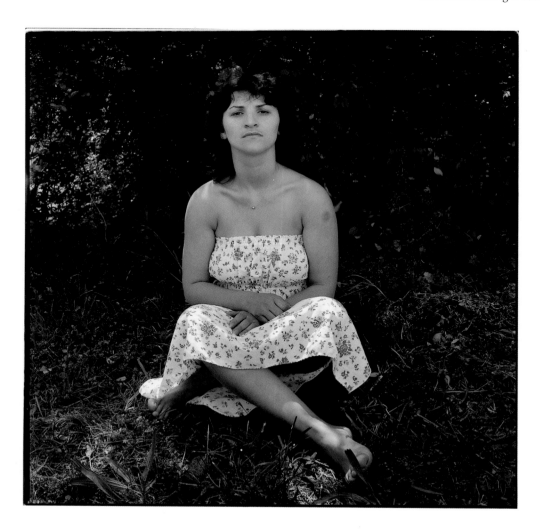

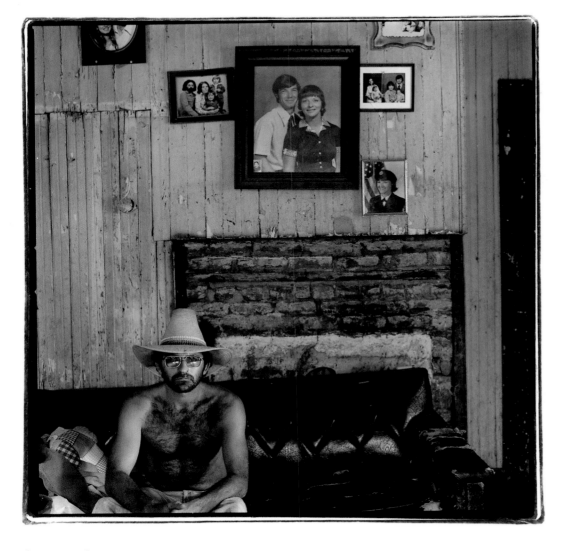

Jerry ○ 1982

Jerry was older than me and he didn't have time to be a little boy. He was like me. When Mama had the first miscarriage—I remember that—she stood up, she was turning a mattress on a bed or something...

She told Jerry to go to the store to call a taxi, she had to go to the doctor. That young'un, he was thirteen, he run up—it was a quarter or a half a mile—and he was back in no time. But Mama stood up and it fell on the floor. It scared the heck out of all of us. I remember he took care of the family so much. Daddy always drilled it into him, "Listen, when I'm gone you take care of Mama and them. You take care of your brothers and sisters, you take care of them." And he still does to this day. —MARY

I was six and a half when I got this cut on my face. But I still remember that night because Daddy came home—it was New Year's Eve—Daddy came home, him and my Uncle Jack, and he said, "Everybody come on. We're gonna get something to eat." So we all got in the car—well, me and Jo-Jo and Lynn did—and when we first got in the car... we had a station wagon, and I think it was a Aspen or something like that— it was a new car, I think it was the first new car we ever had. And I was sittin' in the back, Daddy had all his tools back there, and the Skil saw kept stickin' me in the back. So I moved it. So I got in front... I was sittin' in Mama's lap in the middle. It was Daddy, Jo-Jo was standin' up in the seat, and Mama holdin' me, and then my Uncle Jack. Lynn was laying down in the back. I remember we was goin' down the road and I was thinking, I said, "God, please don't let us wreck." And we hadn't got down the road two miles I know and then I just seen headlights comin' straight at us. —TINA

I'm the luckiest person on earth, because if I had been sitting in the back, the Skil saw would have went right through my back. So I think I saved, God saved my life. Somehow I must have had the feeling we were fixing to wreck.

People talk about angels, and I say, Yeah, I believe in God. He was watching out for me. —TINA

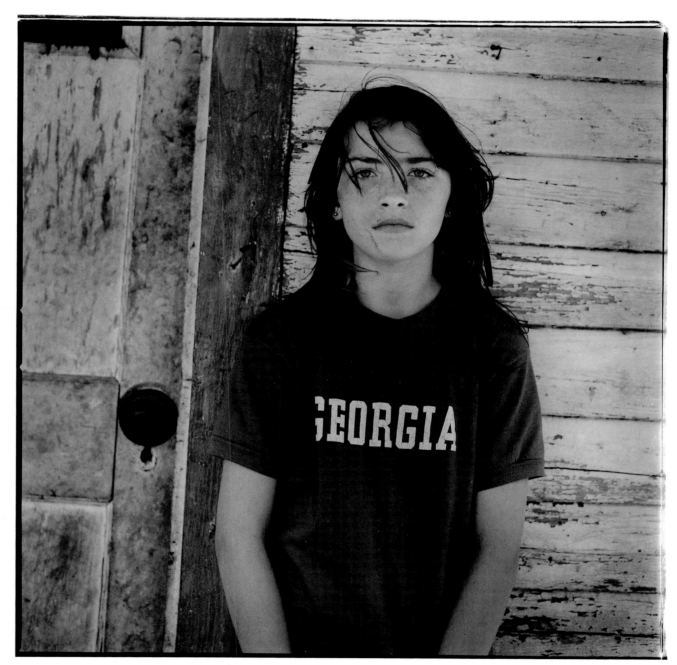

Tina ∘ 1981

Me and Jo-Jo and Tina, when we were little, whenever
we'd find dead frogs or stuff out in the yard
or birds and stuff, we had this little place
under this little tree where we'd go bury 'em.
We'd go and have 'em a funeral, because
we'd see funerals on TV and went to funer-
als; we thought everything was supposed
to have a funeral. So we had funerals. One
of us'd be the preacher and they'd preach it,
and another'd sing the little song, and
we'd bury 'em. Most of my memories are
good. —LYNN

Tina ∘ 1981

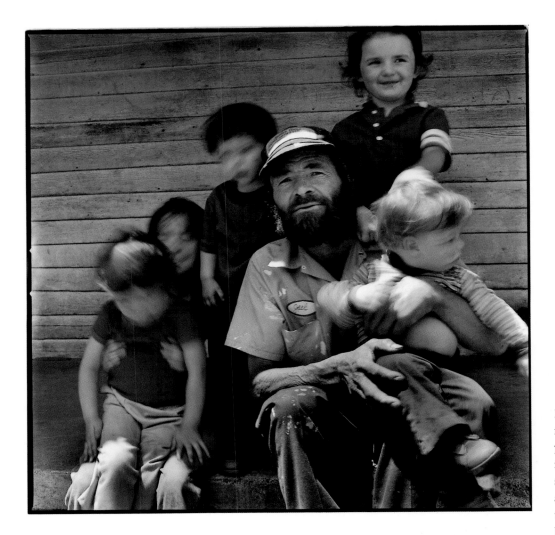

He did the best that he could. I realize that, you know, because you try and raise seven kids on a meager income, you've gotta stretch a dollar. And he kept us all clothed... shoes. We were taught to take care of what we had. We'd get home from school and pull our school clothes off and put old clothes on. Then you go run and rip if you wanted to, and tear them up. But that's all you had. You had school clothes in the fall and you had to make do. And the whole family was like that. —JERRY

Joel with Tina and his grandchildren ○ 1981

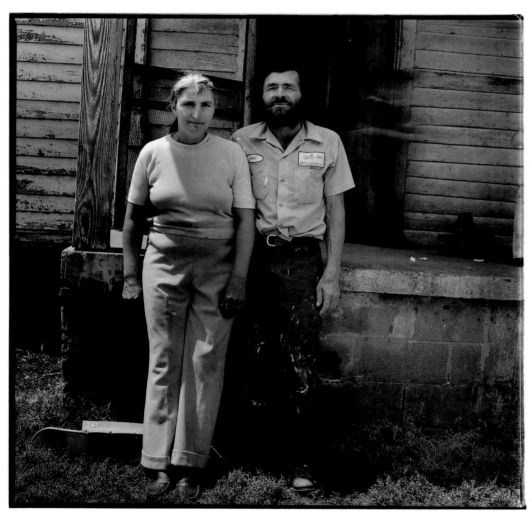

Daddy wasn't no school-wise educated man, but he was smart. He had a lot of common sense to figure things out. He was one of the best carpenters I ever... I think he was the best. He set up and made the prettiest cabinets and put glass doors in 'em and put a lazy susan in the corner of the base cabinet, and did the whole thing with a table saw and Skil saw by himself. He taught me enough that when I quit with them and I went and got another job, that I was one of the best carpenters that that guy had. —MICKEY

Lois and Joel ○ 1981

LOIS: I remember a lot of things about my daddy... He was sweet. He was gentle, and
tender-hearted. He was tall and he had black hair and gray eyes. He was about six foot.
He'd give you the last shirt off your back. He'd help anybody he could, any way he
could help them... Mama was seven months pregnant when Daddy died. They said my
daddy was poisoned. He was bad about drinking back then... After his mother died,
he always drank pretty regular. And he had this friend, and his wife and daughter, and
he'd take them to church or the doctor or anything, and I didn't know it—none of us
knew it—but they were having a love affair. And her husband, he poisoned Daddy. He
put strychnine in Daddy's green beans, he set the table, fixed plates with food in them,
and tea and coffee or whatever, and he told Daddy which place was his and Daddy sat
down to eat. He made it home and laid outside on a cot on the porch all night, and the
next morning my uncles went hunting and they found him out there. They took him
inside and called the doctor, and the doctor told them he thought it was poison. They
didn't do any tests. Nobody ever said anything to the law about it. As far as I know,
he never was told on.

 I was only seven at the time.

 Well, the day my daddy was buried, we moved in with my granddaddy, which
was my mama's daddy. So they helped raise us. And in '44 or '45 she started drawing a
check because my daddy was in the service from 1918 until 1921... which wasn't but
$72 a month at the time, but it helped a lot.

 I've had it rough my whole life, mainly 'cause of being brought up without a
daddy. See, when he died, the very next fall, my sister and brother, we had to help work,
you know, we worked from then on for what we ate. From the time I was seven and
a half... plant cotton, tote cotton seed; plant corn, tote corn seed; cut stalks, and stack;
pick cotton, chop cotton. We even got out and picked blackberries to take and sell and
buy flour and meat. Fatback and meat to put on the table. And coffee.

VAUGHN: I heard some stories that your mother was kind of a mean person.

LOIS: Yeah, she beat us with sticks. Or old thornbush stems. Beat us with belts. She was
cruel to us. Her mother told her the only reason she was so mean to us and did us
that way was because our daddy died and she had to raise us by herself. Which there
might have been some truth to.

 I had a rough childhood, but, all in all, it was pretty good, I guess... We didn't
have too much. We didn't have many clothes. I had three dresses, one for church,
one for school, one for play. We went to church. We survived. I guess we were close
because some families had more than we did and that brought us close.

Grandpa's name was John Toole—John Henry, I believe. He was married three times, and every wife was named Mattie. Daddy's mother's name was Mattie Mozell Grimes, and she died when Daddy was about seven years old. That's when Daddy had to quit school like in the first, second, or third grade—to go to work to plow horses and mules and plow the gardens and stuff. —MARY

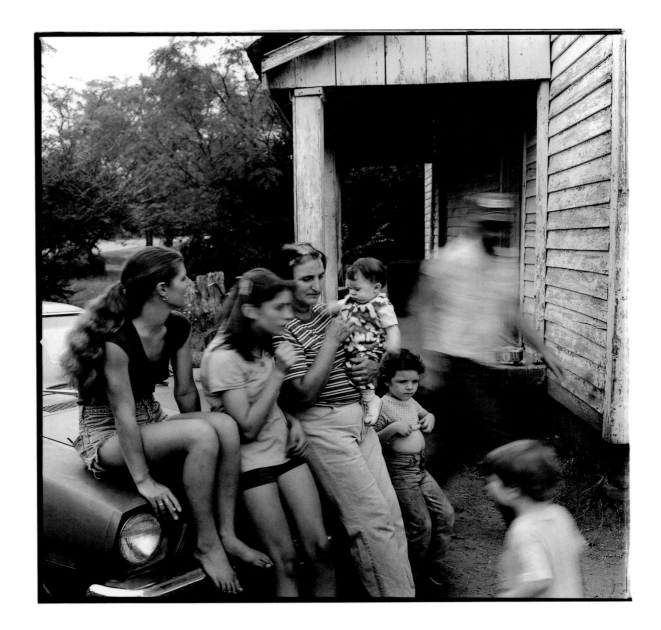

Tina and Lois with Angela and Mickey and his family ◦ 1982

Grandpa died in early '64. His name was John Henry Toole. My grandpa had been real sick.
He was sixty-three. I remember when he died. I remember they
wouldn't let them bring him home. Back then, they'd bring everybody
out to the house and people'd come over and sit up with him. She
[his third wife, Mattie Mae Butler] wouldn't let them bring him home.
So Daddy told them they could bring him over to the house. They
did. We didn't even have a coat to wear, and it was cold. Daddy went
somewhere and borrowed the money to get me and Alice a coat.
They bought Mary and Jerry one 'cause they were in school and had
to have one. But we never did get out the house much so we didn't
have a decent coat to wear. So Daddy bought us a coat. The first coat
I remember ever having, brand new. Then when he died, and they
buried him that day...

I don't remember that much about him, a whole lot, but he was
always... He didn't want you right up under him, but yet he didn't
really push you away either. He always cut our hair, and Daddy'd
give me a quarter, and then I'd pay him a quarter. But he'd stand you
up on a chair up under a light and cut your hair. If you moved he'd
pop you on the rear and say, "Straighten up, boy." He was a real
strong little man. He was kinda hard on Daddy.

Mama and Daddy was married, and they had raised a crop that year.
They had made enough money to get 'em a stove, refrigerator, and
kitchen table, and I believe he said he was gonna have enough to
get him a mattress for his bed. 'Cause they didn't have nothing. The
way I hear it, Grandpa went down there and sold the crop. Grandpa
went down there and took the crop and sold it. He come back and
I think he gave Daddy just a few dollars.

Daddy never did say a whole lot. He never would talk real bad about
his daddy. You could tell it bothered him. He didn't understand why.
He always said Grandpa was just a real hard man. —MICKEY

Lois with Angela and her sister ◦ 1982

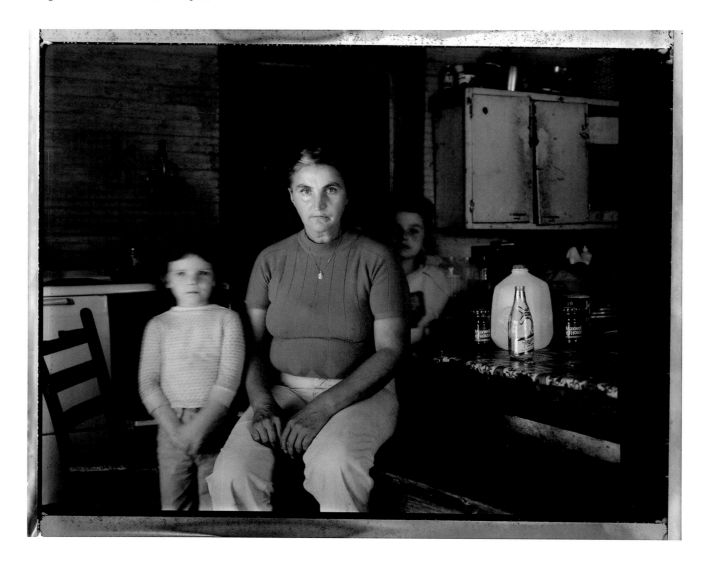

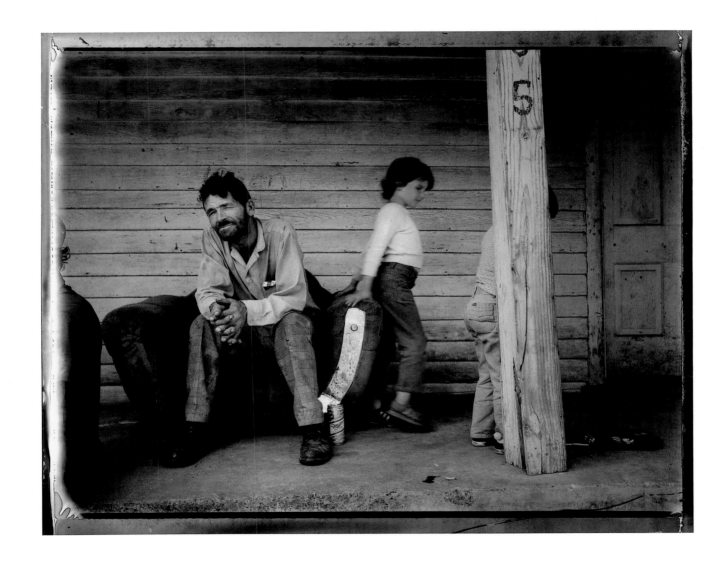

Joel with granddaughters ○ 1982

Once I wrote a story, it started off with this dog. We had this collie dog and it died. This collie—I think her name was Lassie, and that was when Lassie was on TV...

And in the story, it was Mama and me and Jerry and Mickey, and Alice was the baby, and so Lassie was just a little tiny thing, and she died. And at the house where we lived we had this line of crab apple trees, and we buried that dog and had its funeral at the end of the last crab apple tree. And I remember my great grandmother died and Daddy whupped us because we were running around the back of the house that night. I sat up with the women inside as long as I could.

I was about seven or eight. And then when my grandpa died—part of that was in the story because, you know, they brought his body to our house—I sat out in the preacher's lap... And then Billy died and then Lisa died. But it was from a eight-year-old's point of view... I called it "Lesson in Death" because it was a lesson in death for me. And then after that it seemed like we were always going to funerals.

—MARY

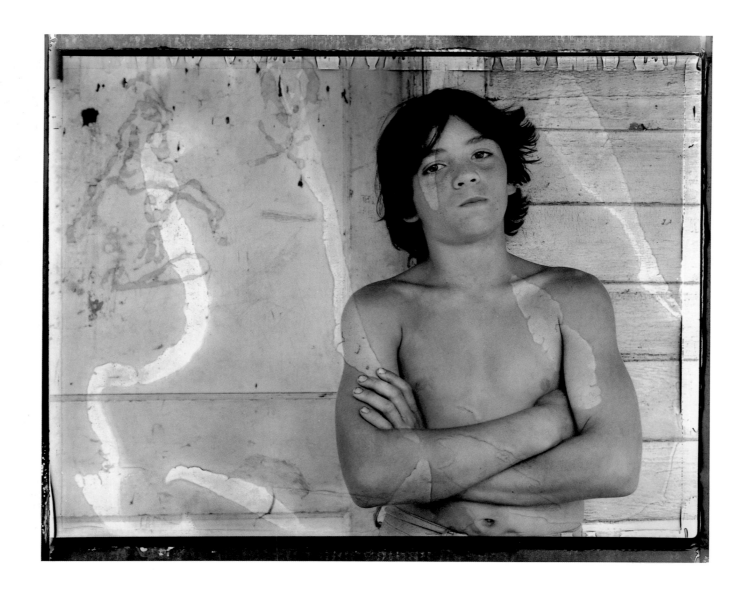

Joe ○ 1982

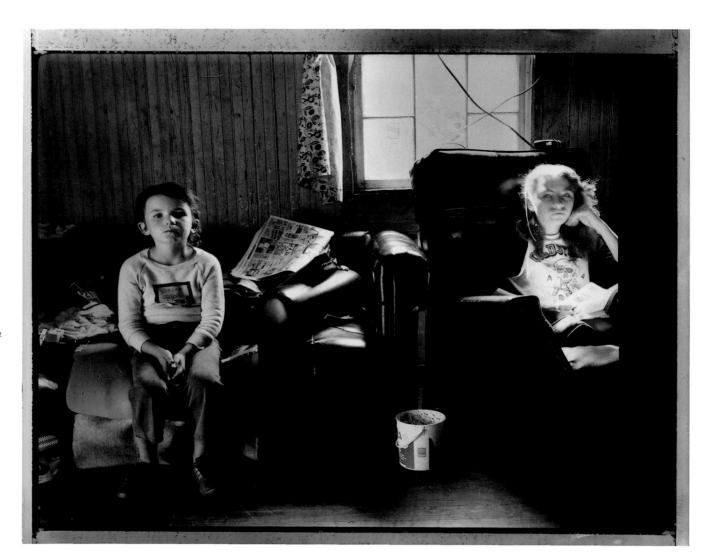

Tina with her niece ∘ 1982

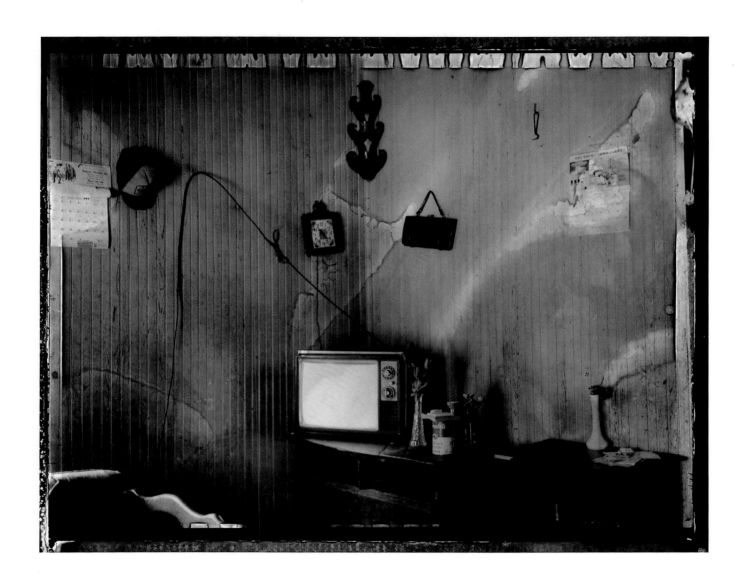

The living room ○ 1983

Angela and her sister ∘ 1982

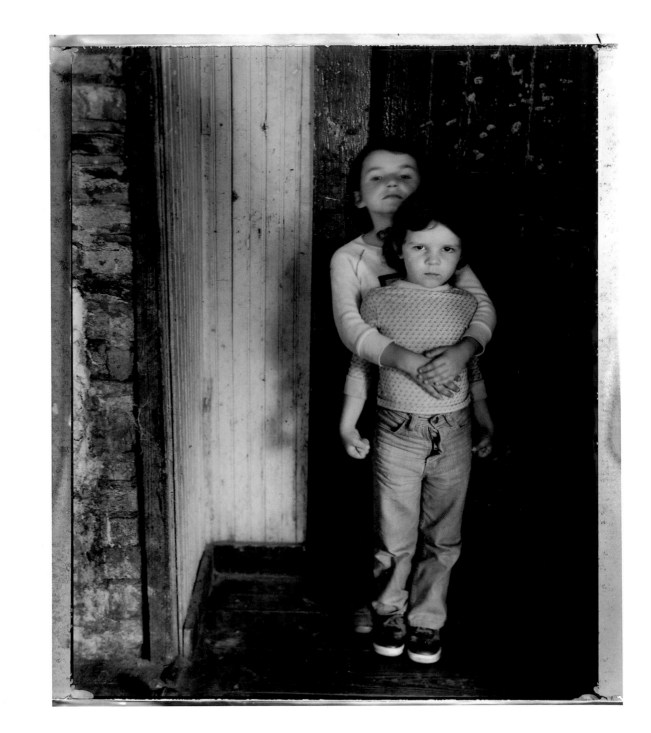

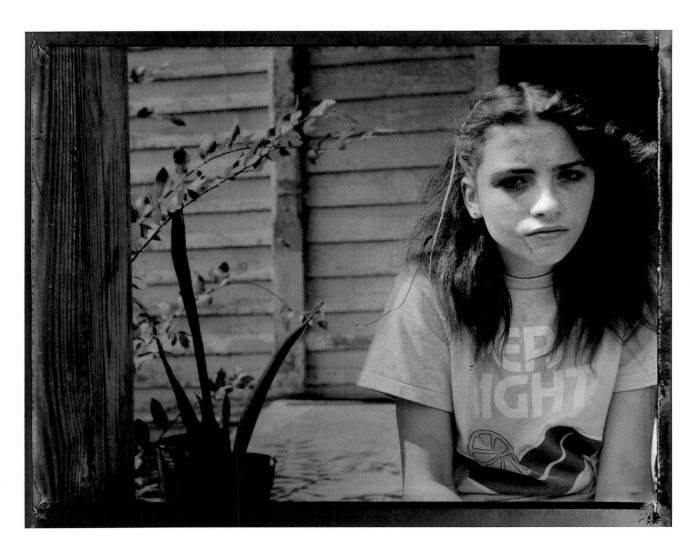

Tina ∘ 1982

It was like Lynn had to be an adult so quick. I mean, all of us did. We weren't like little kids. That's why I was tellin' you about sex. We knew what that was before we started school. All of us had to just grow up real fast, especially Lynn. All of a sudden she was Mama and Daddy both, and plus she was still a little kid, plus she had to take care of Tina and Joe. For the whole time since we left Lynn has been like mama and daddy to Mama and Daddy and to Tina and Joe. She always took care of Tina and Joe. Lynn's gone to the grocery store and bought groceries for the family since she was real little. She's real strong, has a very strong personality, too. —MARY

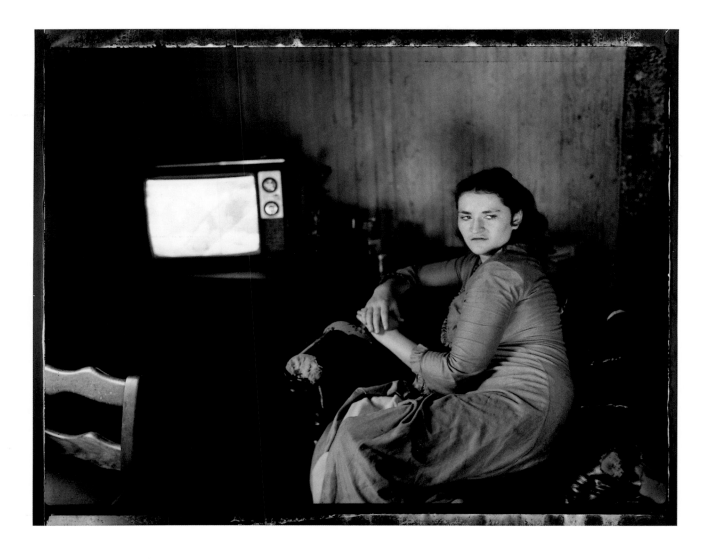

Daddy was the strong one always, you know, he had to be. I don't actually remember Billy dying, but along in there I know he was in the hospital, you know, and I was like eight or nine years old. Well, he died in '64, so I would've turned eleven in '64, so I would've been ten years old. But I remember that year—it was real hard because Grandpa was in the hospital off and on for about a year before he died. He'd come back home and go back to the hospital. Daddy was kinda the oldest kid in the bunch to look after those folks up there because Grandpa had remarried and had another family, and the rest of Daddy's sisters and brothers had all moved down here. His full sisters and brothers had all moved off, and Daddy was the only one hanging close to Grandpa. And I remember that because to me, at the time, I just didn't think they cared as much about Grandpa as Daddy did.

Then Grandpa died, you know, and Daddy was with him in the hospital room. I don't remember much about that. I remember Grandpa— they brought Grandpa to our house and put him in our bedroom for the funeral, lay-out and all, and everybody'd come, and I was so little... I remember going to the church and having to get up and walk by the casket and going out and at the time we went to the graveyard and they buried Grandpa, I know it kinda hurt Daddy a little bit. He said... Daddy said he dipped water out of Grandpa's grave before they buried him because it was bad weather, and he had to help cover him up after the funeral, and that's... I guess in the olden days when you buried your own that was acceptable. You did that. But it seemed to me like Daddy was always... you know, he was the strong one out there.

I remember the morning Lisa died. I heard somebody screaming and all, and me and Mitchell slept in the back room back there. I jumped up and went through there, and Mama was sitting up in the bed holding Lisa, and she said, "My baby is dead! My baby is dead!" screaming. Daddy got up, just like, you know, he had to do. He had to call the sheriff and get the coroner down there. Little impact points like that kinda hit you—little things. I remember Daddy... Like I say, Daddy got up and went and did what he had to do. —JERRY

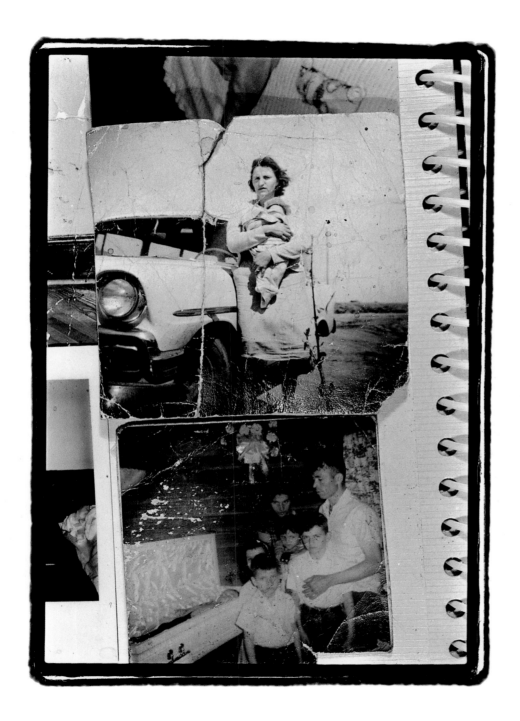

Family album page ○ 1983

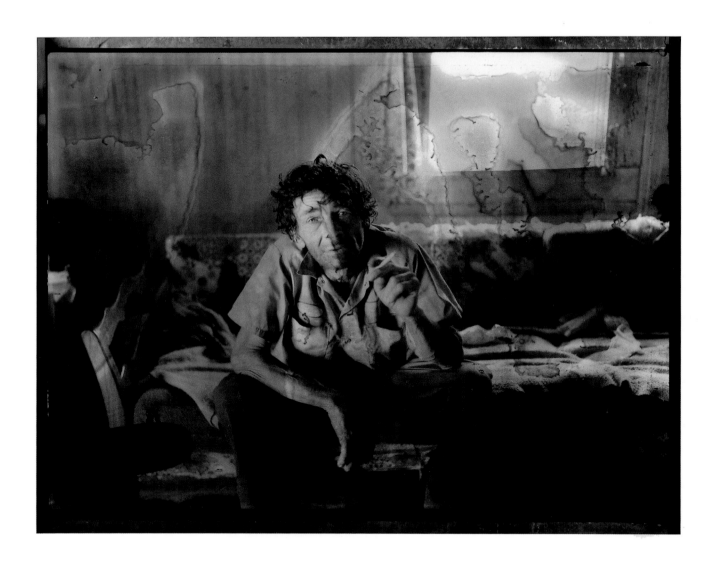

Joel ○ 1984

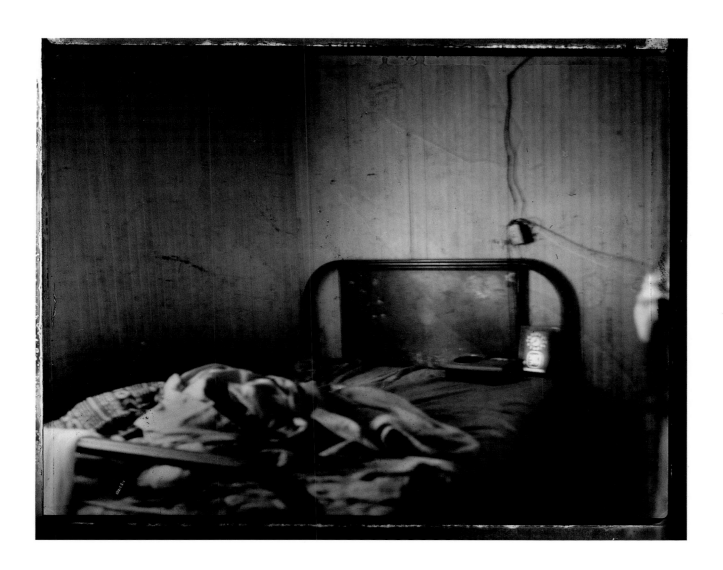

The bedroom ○ 1984

Grandpa died in '64 in February—I think February 26. Back in those days they didn't take all the bodies to a funeral home. They brought him to our house, because his wife and kids didn't want him over at their house, so they brought his body to our house and rode out two miles before they buried him.

Yeah. I remember it. I was eight years old. And then March 31 was Easter Sunday. That's when our house burned down. All these years we thought it was from a wood heater. It was Easter Sunday morning and we left to go down to the store to get some eggs to come back and boil them and have an Easter egg hunt. And at the store, you know, they saw the flames and stuff and smoke and stuff from it, and so when we went home, it was our house. So we got another house a couple of miles down the road. And then Billy died in April. He died April 20, I think.

Less than a month after the house burned down, Billy died. Billy Joe. This was who Jo-Jo was named after—his name was Billy Joe. He would have been two in July. July 10.

They said that out of all us kids that he was the only one that was allergic to penicillin. And back then they didn't have ampicillin or amoxicillin and all that kind of stuff, and they said he was allergic to it. He had pneumonia, and it developed into staph pneumonia—fluid built up and stuff. And Mama was pregnant during that time. And then Lisa was born on September 4, and she died like on October 19. She was six weeks old. I remember me and Mama taking her that Saturday to the doctor for her six-weeks checkup. And he said she wasn't sick or nothing and had a little cold and gave her some vitamins that they start the babies on when they're six weeks old. And that was Saturday and then early Monday morning about four o'clock Mama woke up and the baby was laying there with a puddle of blood coming out of her mouth where she hemorrhaged. And she slept with Mama—Mama, Daddy, her, and Alice. Alice was on the outside. The man came and got her and put her in a little black box. I remember that so well. And see, I just had turned nine in September, four days after Lisa was born. So at that time I was already nine. —MARY

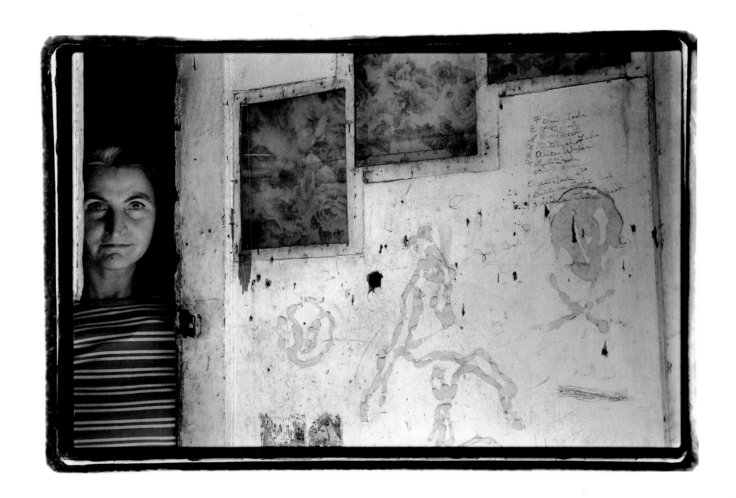

Lois at her front door ○ 1983

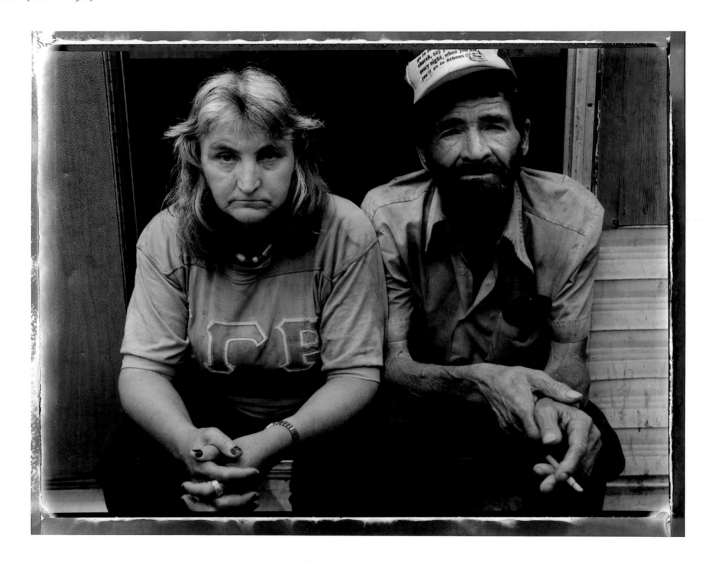

Him and Mama used to... I'm not sure whose swing set it was. I think it was Mickey that got the swing set for Michael and Melodie and had it up there, and I remember I'd get off work or stuff and go up there and see Mama and Daddy sittin' up there in the swing set together talking, just their time. This was after all the kids got grown. It'd just tickle me to see him and Mama sittin' in that swing. Or come down here and see Mama and Daddy sittin' on the porch. Then when he got all those cans out of the dumpsters down there after they moved up here last year, him and Mama'd walk down there to the dumpster. She'd go with him and they'd collect the cans and come on back home. You'd catch 'em holdin' hands.

Yeah. You'd still catch 'em foolin' around in the afternoon. I'm serious. I couldn't believe that, for all those years. —MARY

Lois ○ 1987

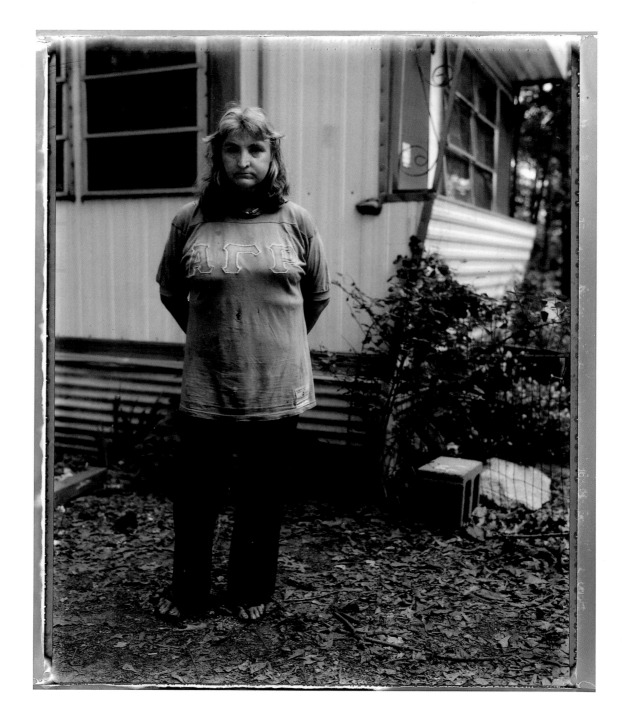

Me and Lynn took Mama to the doctor right after Mother's Day about three or four years ago.

Mama did all kinds of stuff right in there. She shot at Alice, she tried to cut Lynn with the butcher knife, she cussed me and raised hell at me all the time anyway, but mostly that come to wackiness and violent storms after I done left. Most all that did. She wouldn't remember doing nothin' like that. She did. She tried to shoot Alice with a handgun. She done something to Mickey, tried to shoot him, too, I guess. She tried to set Suszan on fire. She poured kerosene on her and was fixin' to throw a match on her.

What else did she do? She tried to shoot Daddy a bunch of times. She missed Daddy one time and almost hit Mickey. I think that's what it was. She tried to shoot Daddy and missed him and almost hit Mickey. All this happened after I moved. She's cussed Jerry out plenty of times, too. Just all sorts of crazy shit.

Daddy told us to take her to the doctor. We had been talking about it a long time before that, but we thought that they would send her to something like a state mental hospital or something, and we didn't want her sent off. Daddy didn't want her sent off, and didn't nobody else want her sent nowhere. And when Daddy told us that time he said, "Look, take her and get her some help. Tell them to keep her as long as they have to to help that woman." We took her down there, and I got so mad I cried. I cried because I was mad, to keep from cussin' them out. They were going to write her a little prescription and send her home. And Lynn sittin' there telling them about this stuff, me telling them about this stuff, and he's sittin' there, Well Miss Toole, so-and-so and so-and-so, acting like he didn't believe a damn word we said. We were in there about fifteen minutes at the most.

He gave her a prescription. Mellaril. Or something else, it might have not been the Mellaril. But it was something he gave her a prescription for. I stood up, I lit me a cigarette, and I paced that little floor, and I was sittin' there wanting to cuss him out so bad. I love my Mama, I really do. But she tried to kill Daddy, and he couldn't do for himself and she was just raisin' hell with everybody, cussin' everybody out. Something just had to be done. —MARY

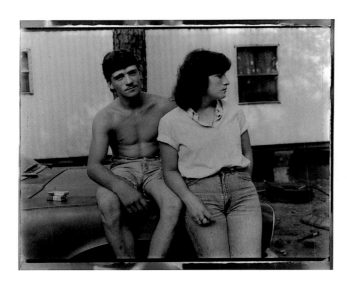

Joe and Tina ○ 1987

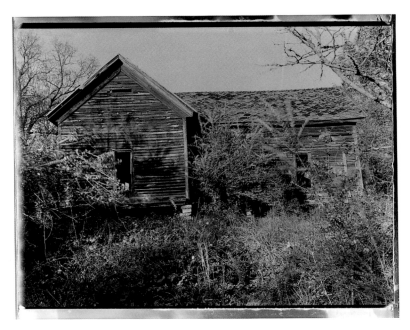

The Tooles' home in 1964 ○ 1987

After their house had burned down in 1964, the Tooles moved into a house down the road, where both babies Billy Joe and Lisa died. Joe and Kerry took me to see that house, now abandoned.

KERRY: ...and that right there was the food closet where they put the food and stuff inside. The stove was somewhere along here, and that right there was what I was talking about with Suszan—they got these little ponies, little beer bottles stuck down in there. That's the ones Papa would give to Jo-Jo and them to drink when they were little.

JOE: Mama fell through this thing one time. There was a place right here or something, and Mama stepped through that. We had a hen that got to laying right under the hole. So Daddy cut the hole right there, and in the summertime all she had to do was open up the hole and reach down and get the eggs. Then she'd just cover it back up and just lay a piece of wood back on it.

KERRY: Then she got to where she'd just pour things down in there, trash and stuff, and that's how those pony bottles got down in there.

JOE: That linoleum right there, we used to have a table... Daddy built a kitchen table and put that linoleum on it, over the table. That bench we got down at the house? That was the bench that went to the table. That bench is old. It was right here. The sink was right here. There used to be an old doghouse right here. Daddy built an old doghouse from here to the edge of the house; it had a cover over there, and all Mama had to do was walk around and open the door and throw the food over in the dog pen. Mama used to give me and Lynn Daddy's cigarettes; if she didn't want Daddy to smoke 'em, she'd give 'em to us. We'd go out here and hide in this doghouse, and we wouldn't smoke 'em, we'd just play with 'em, break 'em up and stuff.

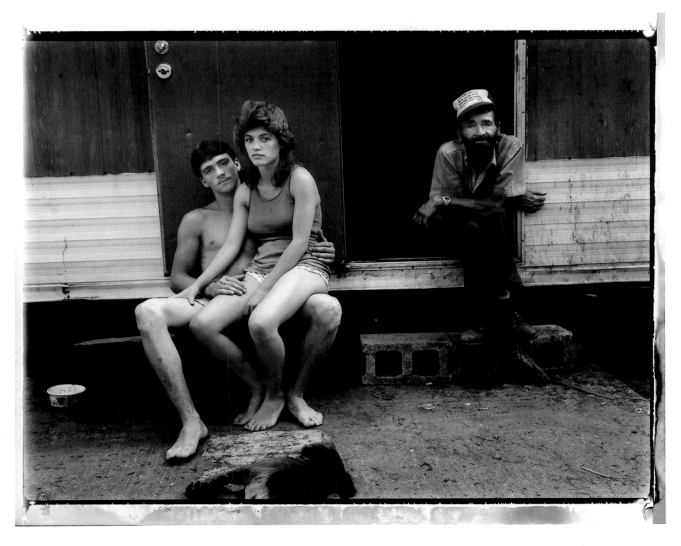

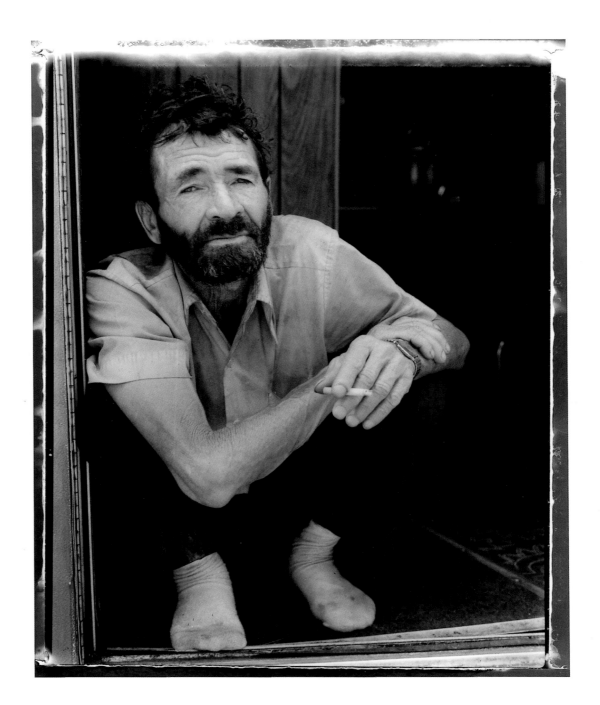

Joel ○ 1987

Joel helped me through a lot of things. I had a lot of problems with my nerves, and he
helped. We'd get out and walk around, pick up beer cans, go down
to the dumpster. When we lived at Hogan's, we'd go down to the
dumpster and find a lot of stuff... radios, hair dryers, a lot of stuff.
We even found a little toaster oven. It actually worked. And a blender.
He gave Lynn the blender, because he said I'd never use it. Which
I don't care much for blenders anyway. I don't know, I think we were
pretty happy. I guess as happy as most couples. —LOIS

Daddy got disabled and Lynn was the lifeline kinda, you know. And Daddy felt
so bad about that. He did, and he felt so useless. And I think that's another reason
he probably died this early too. I didn't expect him to die. But he'd sit over there
and since he was disabled he'd say he wasn't good enough for nobody, he wasn't
no good for nobody. To start with, first when he had to quit he couldn't see. Oh,
I haven't even told you part of the other stories. He had the cataracts and couldn't
see. He went to work with his brothers, and he'd try to tell them what to do but
that just made it more frustrating because he couldn't tell somebody how to do
something if he couldn't see what they were doing in the first place.

So then his lungs gradually got worser and worser and, by the time he had his
eyes operated on when they had moved up there in the blue house, by then
his lungs were too gone, so he still couldn't go back to work. But mainly in the
blue house he got disabled where he couldn't do anything, but he did have
a garden up there and he did do things around the house. He did get out there
and clean up the yards, he got out there and cut grass. —MARY

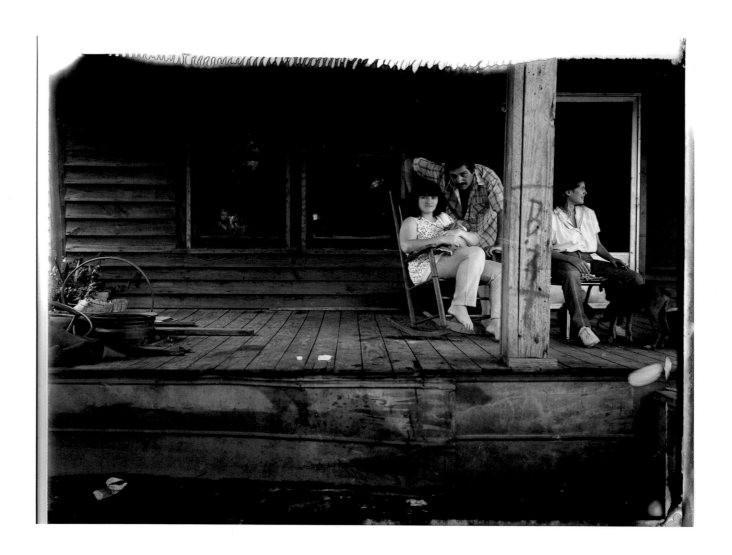

Lynn and Donald with their first baby and Kerry ○ 1988

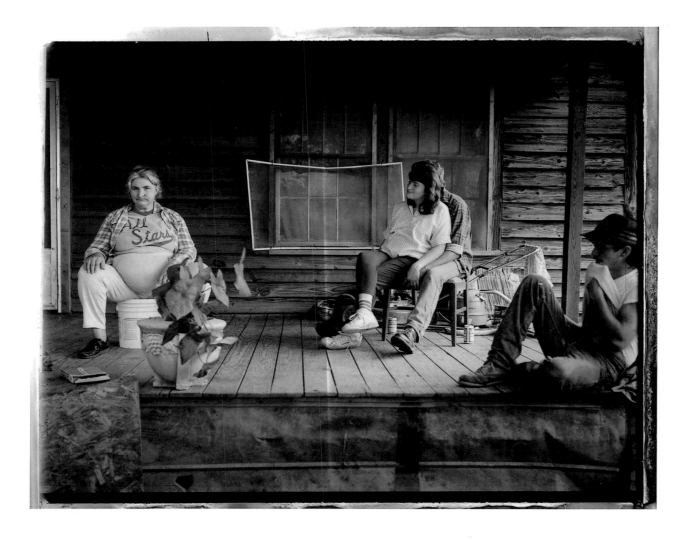

Lois, Tina and Mike, and Joe ∘ 1988

Down near the beach
where the seagulls cry
I looked alone to the cloudless sky

It was way up high
in the purest of blue
where my thoughts
were wandering as if I were too

As I looked down on
the trashed and dirtied world below
I thought of the people
with the uttermost woe

I gave them a warning
as I thought they could hear
take heed of my words
for the end is very near.

Then as I looked down
from my perch above, I could see
there was still some scattered love

SCATTERED LOVE ○ JOE ○ 1985

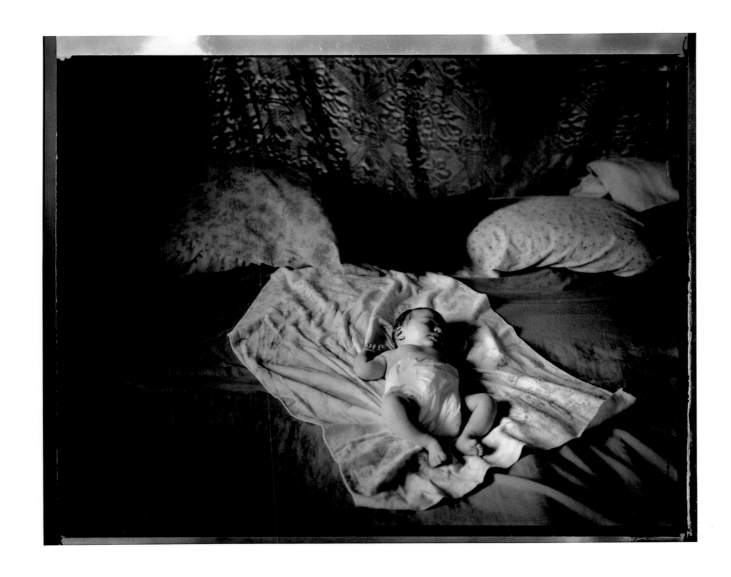

Amber Nichole, ten days old ○ 1988

VAUGHN: Now, what are you smiling at, Tina?

TINA: Tell her how you met Daddy. Tell her how you seen him the first time.

LOIS: I don't know.

TINA: Yes, you do. He was working in the field and they went by in the school buses and she yelled at him.

LOIS: I hollered at him.

TINA: And asked his sister what his name was and then Mama went home and told my granny, she said, "Mama, I seen the man I'm gonna marry today."

VAUGHN: Is that right?

LOIS: Yeah.

TINA: And Big Mama thought she was crazy.

LYNN: See, Tina and her husband met just like Mama and Daddy.

TINA: Yeah, I used to watch him on the school bus. Our school bus come this way and he lived down there.

LOIS: You watched him?

TINA: Yeah.

LOIS: Did you holler at him?

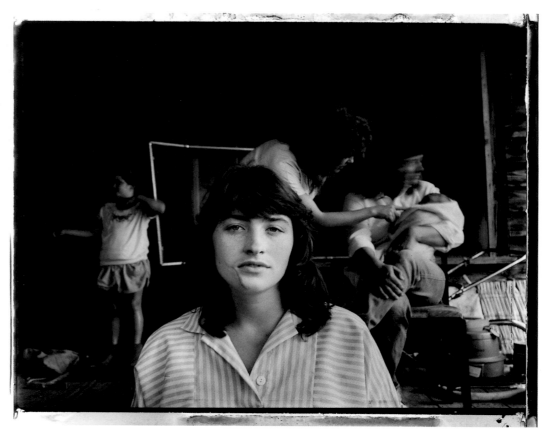

Tina, seven months pregnant, with Melodie, Kerry, and Mary holding Nichole ∘ 1988

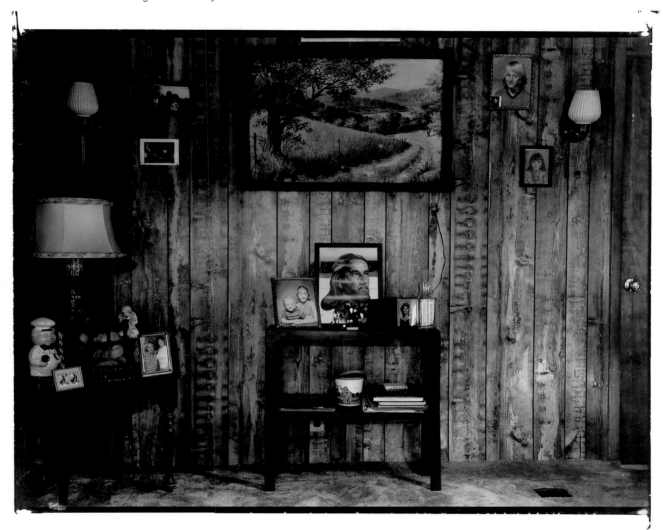

They said she'd never find love,
that she just wasn't the type.
She almost believed them,
until he walked into her life.

She had a life of pain,
a life of heartache and anger.
She had no reason to hope,
and no reason to fear danger.

He lived in a world of crowded homes,
and hostility.
He had no education,
no ambitions, no abilities.

She learned the hard way,
that life isn't fair.
She began to feel resentment,
and eventually to not care.

He fought his way through the world.
Many tears slid down his cheek.
He swore to never give up,
as long as love was left to seek.

It was ironic that they should meet,
on a rainy day at that.
For doomed lives were no longer
the fact.

It started out simple,
but soon became complete.
For they found the greatest love,
one that was very concrete.

They know now that the world
was not meant to hate.
For they were brought together by fate.

The woman and man
whose lives were filled with sorrow,
love their lives today,
and go to bed each night,
looking forward to tomorrow.

TINA ∘ 1986

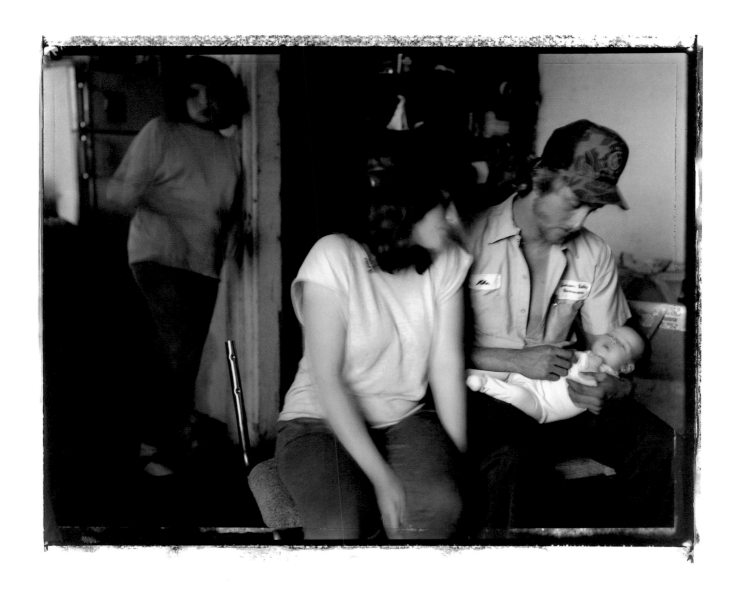

Tina and Mike with their baby Tasha and Tina's niece ∘ 1988

When I married David I was so naive. I wasn't a virgin or anything like that, but I was so naive. I let him tell me everything to do. I was a good housewife. I cooked, I cleaned, I stayed at home, I worked, I didn't go see my mama unless he told me we could. That's just the way I thought it was supposed to be. And then I said, No, this ain't making me happy at all. Even though I was with Jimmy fighting and fussing and all this for the last eight years, I still did what I wanted to. I went to see my mama and daddy when I got ready, I went shopping when I got ready, I made my money, I spent my money. Since we've never been married or nothing like that, he's not like a husband, so I've always made sure that I wasn't gonna be a wife, or a right wife. —MARY

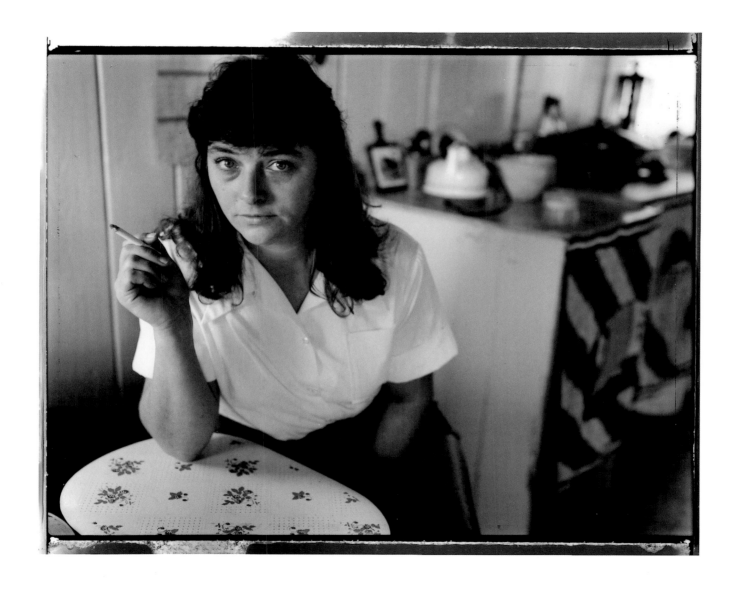

Mary ○ 1988

Mary's house ∘ 1988

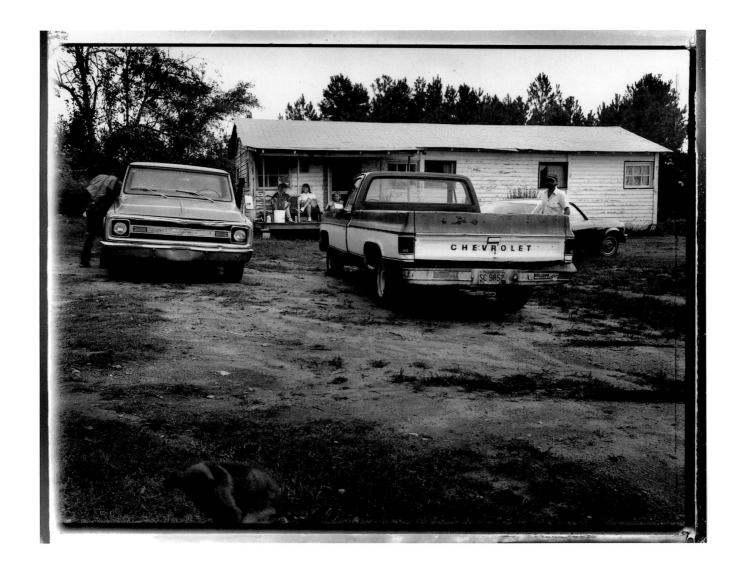

I was joking with Mama yesterday, I was trying to get her to take a bath. She slapped me, hit me on the arm, beatin' on me. I kept on at her. I said, "Mama, I guess we'll just have to put you in a nursing home and let them scrub you. And you know how mean them mean ol' nurse's aides are. They'll just take you and throw you in that tub and scrub you so bad." That made her go take one. And me and Lynn started laughing and Mama said, "I oughtta whup you." She comes over there hittin' on me. I said, "Whup me. I'll let you whup me if you'll just go take a bath first." Daddy'd be the one tell her, "Mama, go take you a bath."

When Daddy got so sick he couldn't bathe himself much, Mama'd go up and say, "Come 'ere, Joel, and let me give you a bath." "No, I ain't messin' with you right now." That was so sweet, though, and so cute. He'd say, "Lois, you wanna go give me a bath?" If she felt like it she'd go give him a bath and then they'd be in the bedroom for a while and need another bath.

— MARY

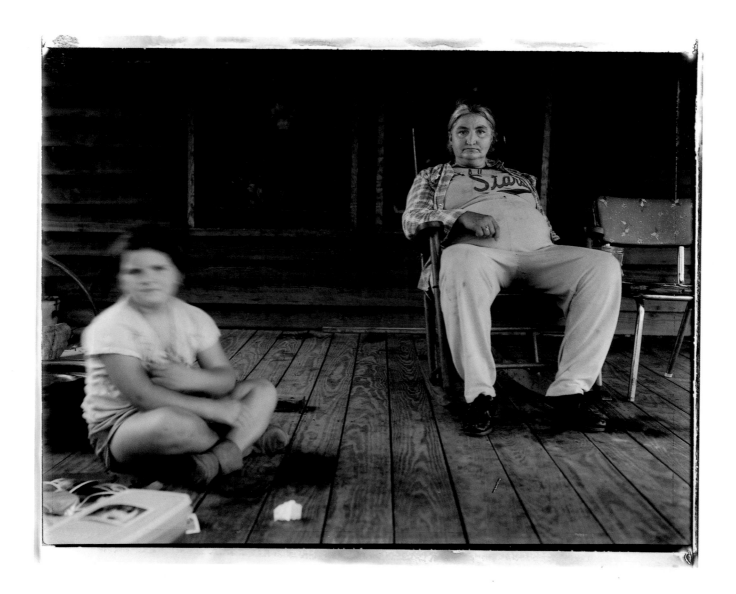

Melodie and Lois ○ 1988

Mama told me the other day she needed twenty dollars for her medicine, so I gave her twenty dollars. They left going to the store. I thought they were going to get her medicine. They came back and they had all kinds of sandwich stuff and candy and junk. Noodle soup, Pepsi Colas... just junk.

I said, "Where's your medicine?" "Oh, I didn't get it." She said, "I'll have to get it tomorrow." She came back the next day and said she needed ten or fifteen dollars to pay the doctor so he would give her a prescription. I said, "Can't you call the doctor and tell him to call in a prescription? That's the way they usually do it." "No, can't do that. I got to pay him before he'll do it." So I gave her more money.

Mama gets money from everybody. She sat out here the other night, she got nineteen dollars from... we were sitting out here drinking a beer the other night and she got nineteen dollars from everybody. I said, "What'd you do with it?" She said, "I spent it." She's been going to get medicine for the last week and hasn't got it yet. I don't know whether she needs it or not, but it'll get to the point where I don't know whether to believe her or not. You don't know if she really needs it or doesn't or what.

I told her the other day to give me the damn prescription and I'd go get her medicine, but I wasn't giving her the money. I give her money, but then I tell her, "You've got to pay me back." Then when she gets a check, I tell her just to keep it and pay the bills with it. The next thing I know she's done give it to somebody else. —MICKEY

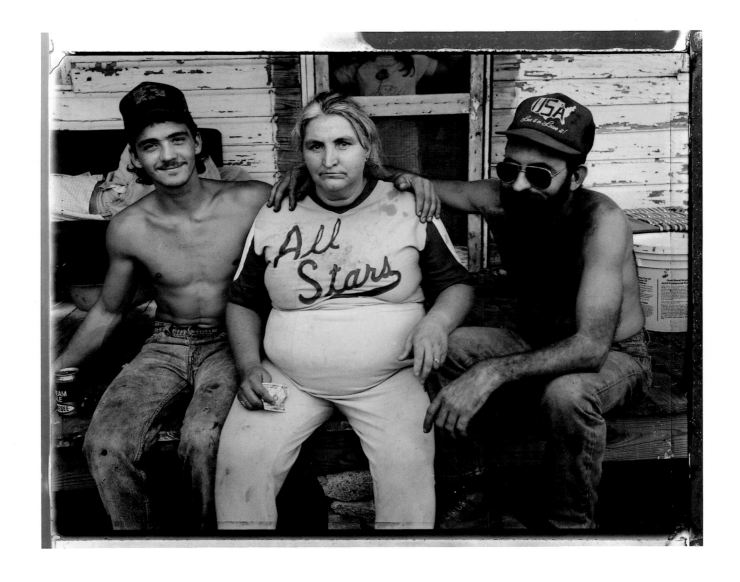

Joe, Lois, and Jerry ○ 1988

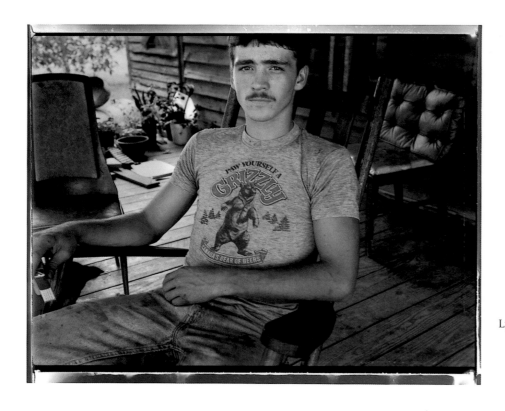

Joe ∘ 1988

Lynn got her a job at McDonald's, but being a cashier or
something like that wasn't enough for her—
frying hamburgers. She wanted to be the
manager of it. So she was the manager's
pet. She'd open for him, close for him, had
anything she wanted. They paid her good
money. They give her more raises than they
did anybody. Then Tina got sixteen, got her
a car, got her a job at McDonald's, both of
'em worked. And then Joe has been working
with Jerry and them since he was younger
and stuff. I mean, totin' blocks and bricks,
doing odd stuff, cuttin' grass, doing any job
and making their own money. But all of
us did that. Daddy put me to work and got
me a job when I was twelve. So we all had
to always work for ourself time we got old
enough. —MARY

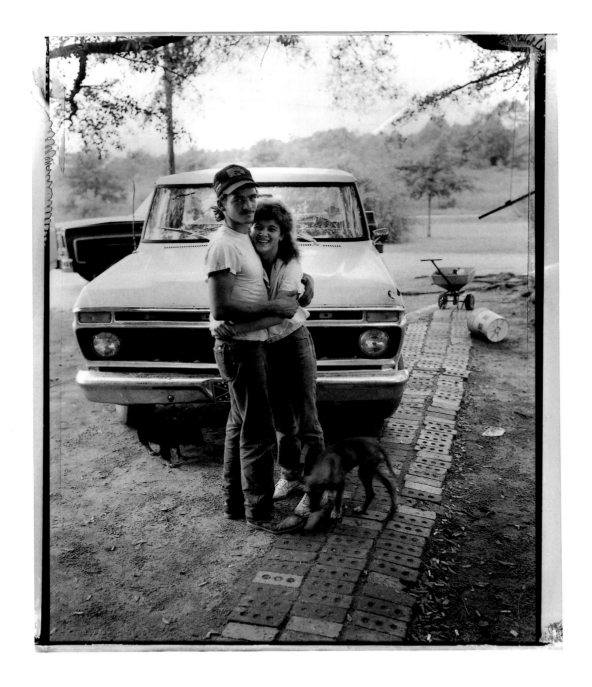

Joe and Kerry, recently married ∘ 1988

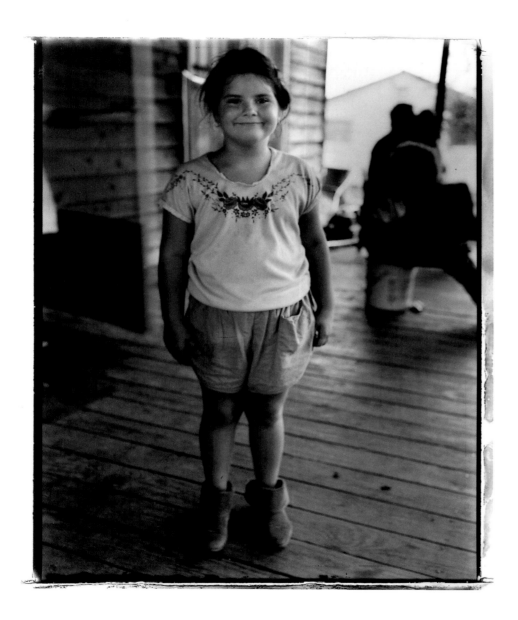

Everybody wanted to have nice clothes and nice houses and nice cars. You know, you go to town and you're riding in an old piece of junk and everybody else and everything they have is new. They didn't care about nothing, not a care in the world, just happy-go-lucky. Yeah, it bothered us. I can honestly say that it did. But it didn't bother me like being mad toward Mama and Daddy or nothing. I know they couldn't help it. I know how hard it was on Daddy. But Daddy never complained. I guess he just took it all in stride. —MICKEY

Melodie ○ 1988

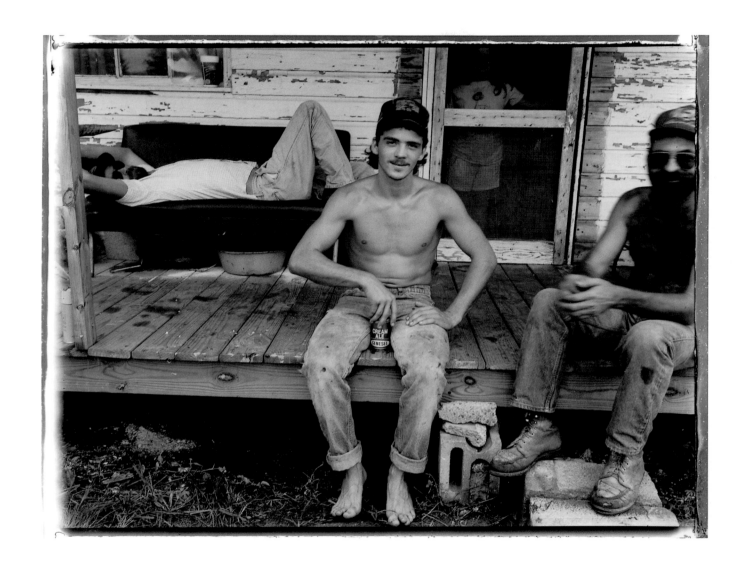

Joe with Mickey, Melodie, and Jerry ○ 1988

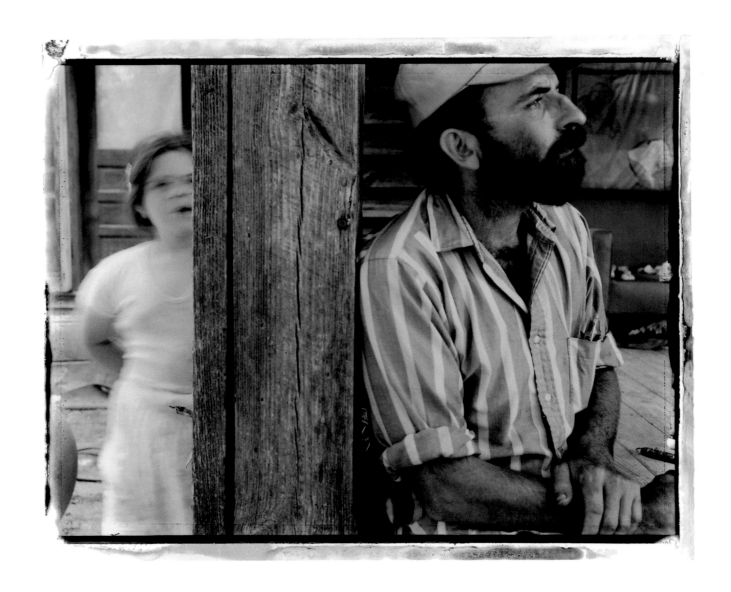

Melodie and Jerry ◦ 1989

JERRY: I wanted to go to college—until I got out of school. When I got out of high school I think I just fell away from it, because to start with we talked to my counselors and they could get me a partial grant to go up there to Demorest, Georgia—Piedmont College at Demorest up near Gainesville— but there was no way. My car was tore up. If the car had been running, there was no way I could've worked and drove the car back and forth up there to school at Gainesville and lived at home, and there was no way I could live up there and pay the tuition and work. So... that was it.

 I couldn't get a full scholarship because my grades weren't good enough for one thing—I had good grades but not good enough—and Daddy made just a little bit more money than you were able to qualify to get a state grant.

VAUGHN: Do you remember what he was making back then?

JERRY: I tell you, it wasn't much over minimum wage, whatever that was, and that was in '71, so it wasn't very much money.

JERRY: We were a bunch of rowdy little boogers. Even though we were poor in our younger days, we were pretty happy. We didn't know what went on in the outside world; didn't know anything; naive, and... Like I say, when I got to high school I started looking around and seeing... I started kinda resenting a little bit, you know, because we didn't have what everybody else had. I think that's normal for any kid, you know. At the time I thought it was a real big deal. I look back now and I don't think that's nothing now.

VAUGHN: Looking at these pictures the other day, you said that they look like "southern poverty."

JERRY: Well, it's surroundings, you know. We came up pretty poor. I mean, you look back at it, me and Mitchell were talking about it one day. I don't think I'd have wanted it any other way. I know what's out there to be had, you know, but you've got so many, like, rich kids coming up, and they take advantage of so many things, I don't think the character's in them from having to do without, they don't appreciate what they can get ahold of nowadays. I think every one of us—every one of us appreciates what we can get because we never had it.

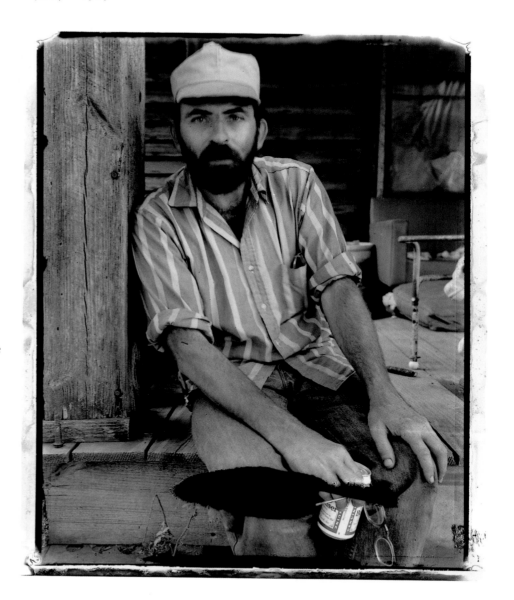

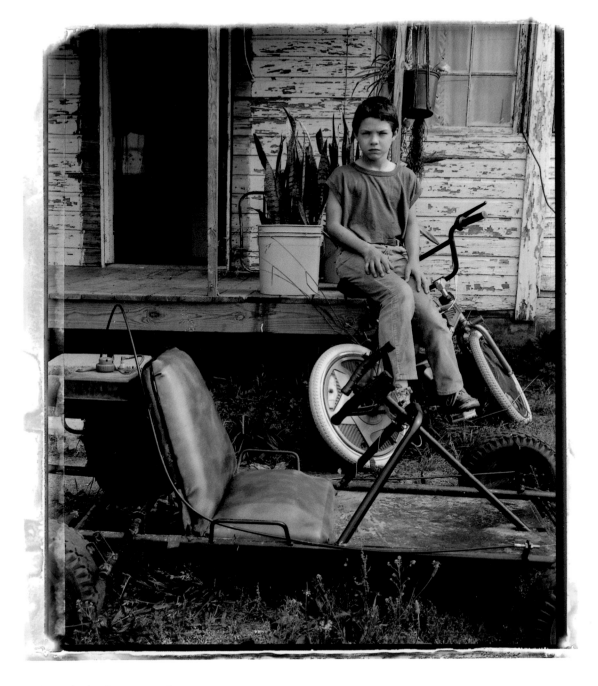

Justin with a go-cart made by Jerry ∘ 1989

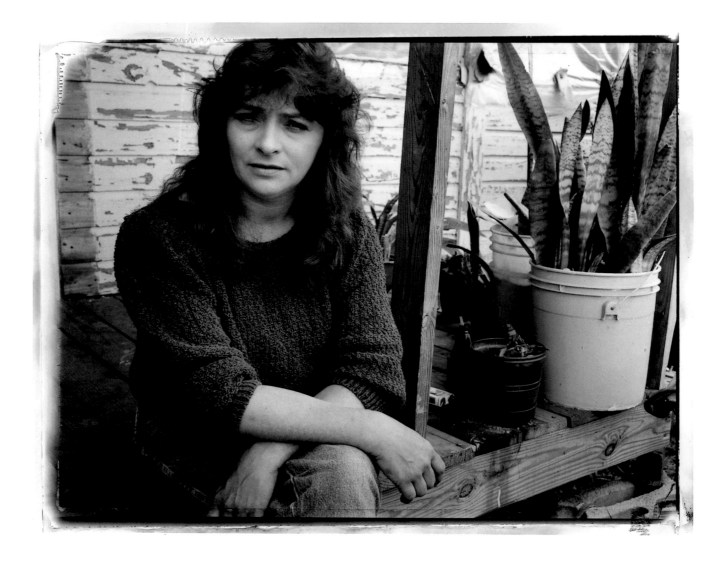

Mary ° 1989

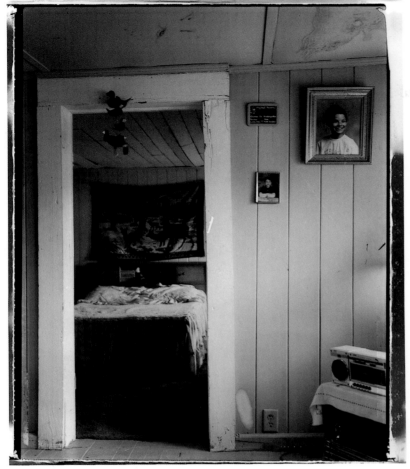

Mary's home ○ 1989

Daddy tried so hard... I mean, we had riding lawn mowers and plenty of food and he'd cut the grass good, and just try so hard. Most of the time all us little kids'd tear up anything he'd try to get us. I mean, he bought Mama a new washing machine, and it wasn't much before it was tore up. He made water go into the house—running water. It was never hot. We always had to heat our water. He did all that and then we'd tear it up or it'd get torn up or whatever, but he tried hard.

I'm not ashamed of them anymore because I grew up and got over it. It don't matter. It was the way we were intended to be. I just had to grow up to realize that.

Justin's so much different from me that I expect things to be a whole lot better. He'll probably grow up and have him a new house and new car, and then, you never can know.

—MARY

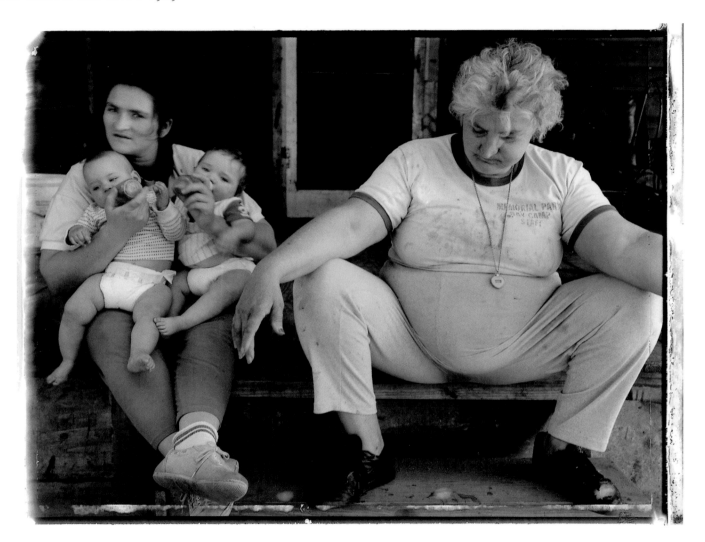

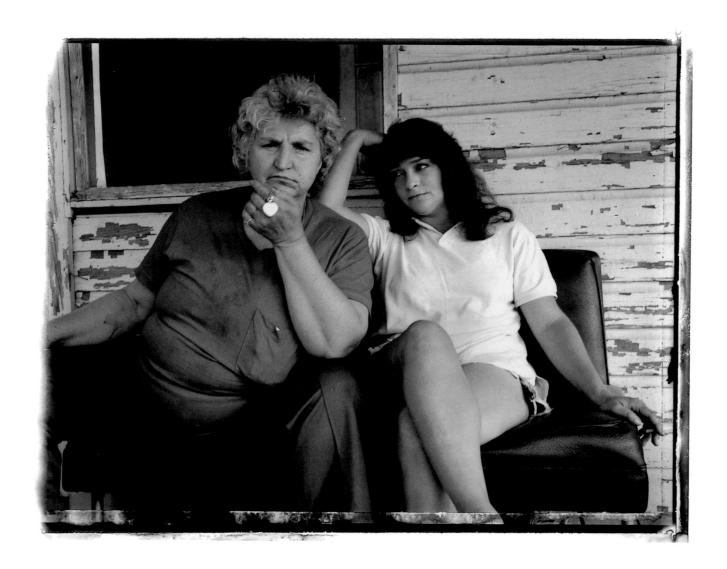

Lois and Mary, Mother's Day ∘ 1989

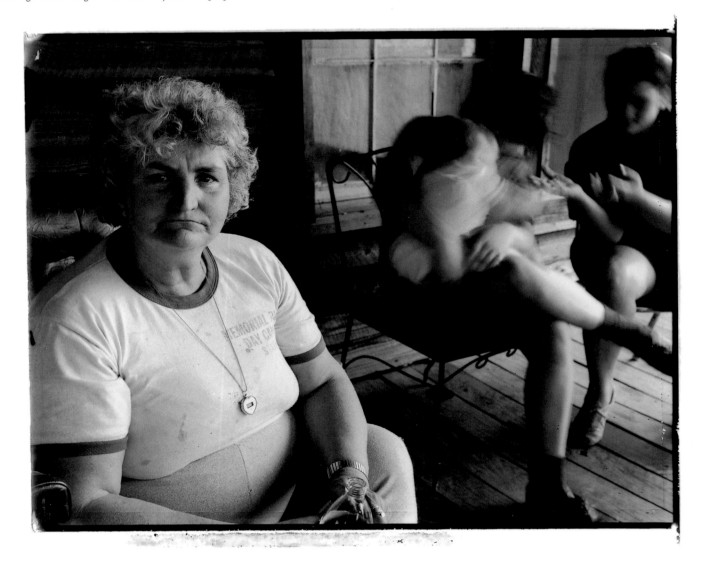

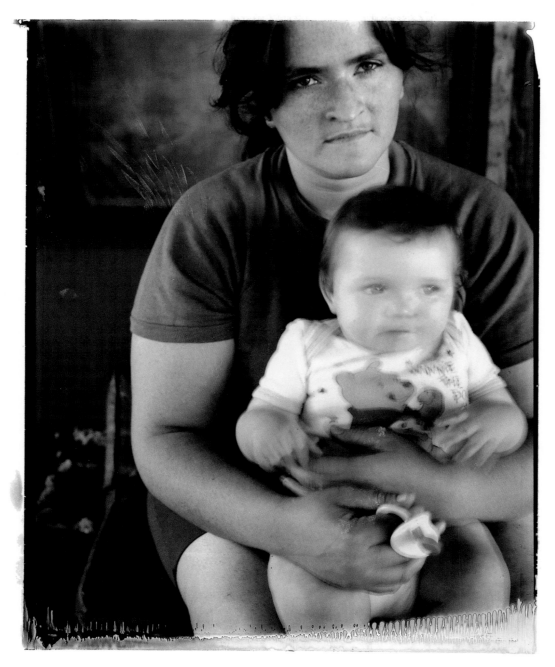

Lynn and Nichole ◦ 1989

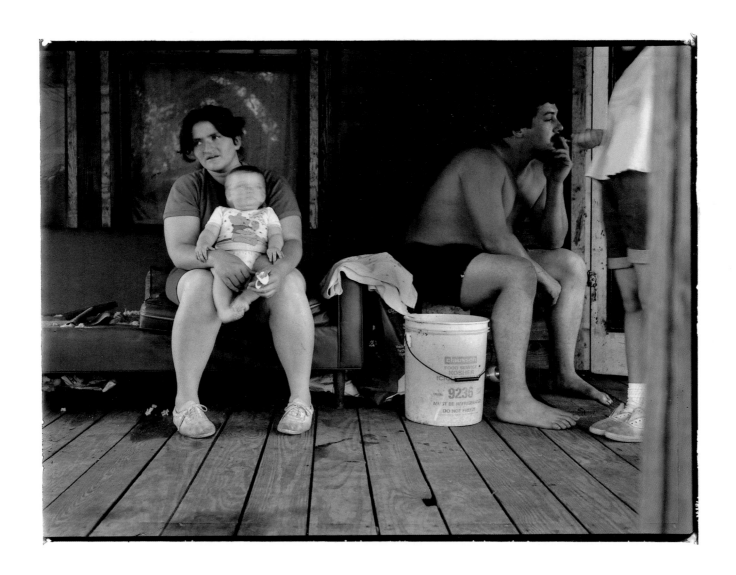

Lynn, Nichole and Donald ○ 1989

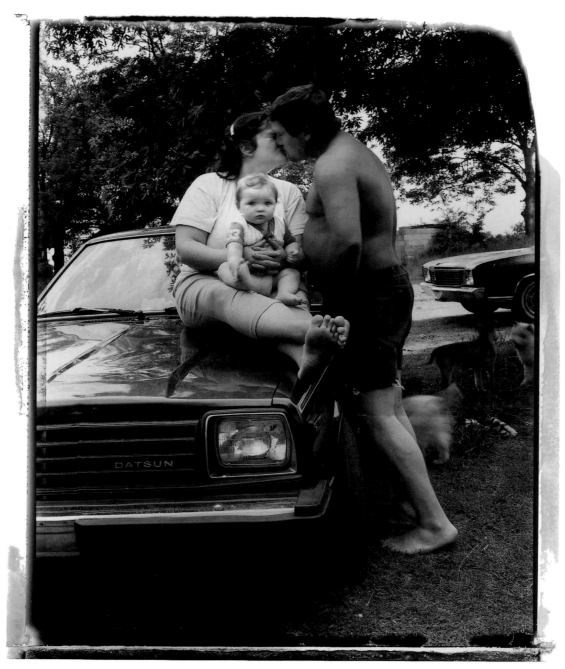

Lynn, Nichole and Donald ○ 1989

I've never loved anyone
quite as much as I love you.
These feelings that I have for you,
are all forever true.

We have our share of troubles,
of pain, and heartaches.
But a light shines past them,
a cure to heal our heartbreaks.

We came together as one,
the day we said "I do."
I still mean those words,
as my heart hopes you do.

We share one common being,
that of a little girl.
She wakes me up each morning,
and brings life to my world.

You've been taken away from us,
and there's nothing we can do.
Yet we know that one day,
you'll return and we can start
anew.

I look forward to tomorrow,
because tomorrow you'll be home.
And in your precious arms,
I'll feel like a queen on her throne.

I long for the days to hold you,
to feel your breath on my skin.
To have you lay beside me,
and hope the night will never end.

But for now my dearest love,
we'll have to hold on to tomorrow.
The day I only dream about,
the day to end my sorrow.

I love you baby.

TINA ○ 1989

Tasha and Tina ∘ 1989

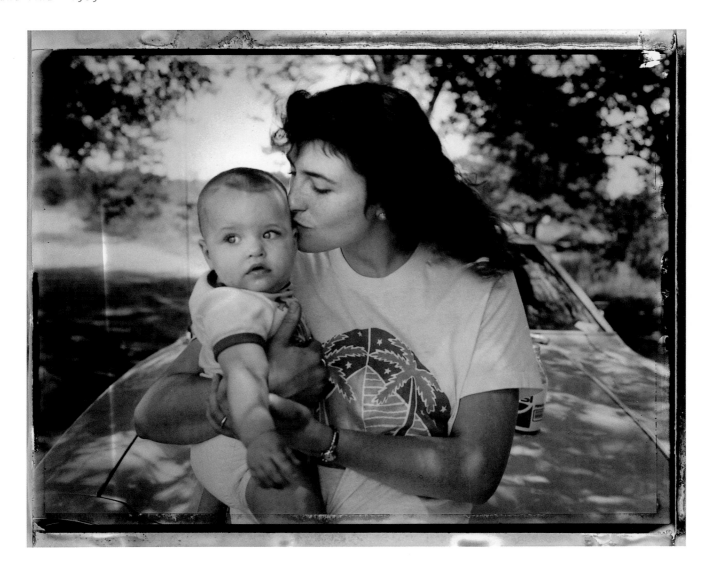

I had moved away from home and was living with Jerry, so I had to work because I was paying half the bills. I did that to get out of the house.

Suszan ◦ 1989

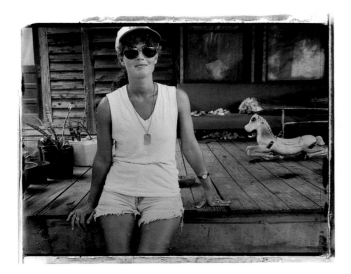

We didn't have no hot water, no bathroom, no nothing, no heat, just a fireplace. So I had the opportunity to live in the trailer, so why not? It was nothing personal; I just had the chance to do it so I did. Then when I had to go back to school, I got a job at Harrison's Poultry working at night with them. I went to school during the day. I got out of school and I'd hitch a ride to town and then I'd work from four o'clock to one o'clock down there. It just got to where I wanted to work and I just had the feeling I wasn't gon' finish high school. I didn't want to. I wanted to work. I was gon' have to work the rest of my life anyway. Look at Jerry. He's done went to high school, he got his diploma, and he's out here laying damn bricks. He's laboring for a brick mason. So why not? Then Jerry and his wife got back together, so I had to move out. So I moved back home. Here I was working till one o'clock at night and coming in to a cold house and nothing to eat, smelling like dead chickens, nowhere to take a bath.

In a big way I was ashamed to go to school; I was embarrassed. It was in the ninth grade. I was working at the Poultry at night and coming in late, so I was real tired. They messed around and gave me P.E. the second period. Here I was about dead anyway. And I come out of P.E. into his class, and it was hot. It was burning up in there, and I had the buttons on my shirt unbuttoned like this. He came back there and told me to button up that shirt. He said, "Boy, I said button up that shirt." So I looked up at 'im and started buttoning up my shirt, and he just snatched me up by my collar and said, "I know that you're already in trouble." He said, "You got to go to school and you're gonna learn and do the work in my class and pay attention." I said, "You let go of my shirt." When I said that he just grabbed it a little bit tighter and when he did I knocked the shit out of him, and I walked out, and I haven't been back since.

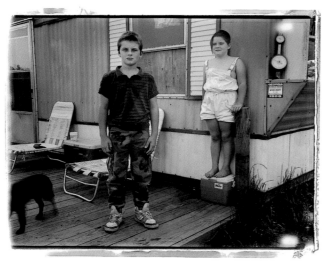

Michael and Melodie ◦ 1989

I left there and went straight to the probation officer up there and said, "Look, you can send me off, do what you want to, but I ain't going back. I don't care what you do." —MICKEY

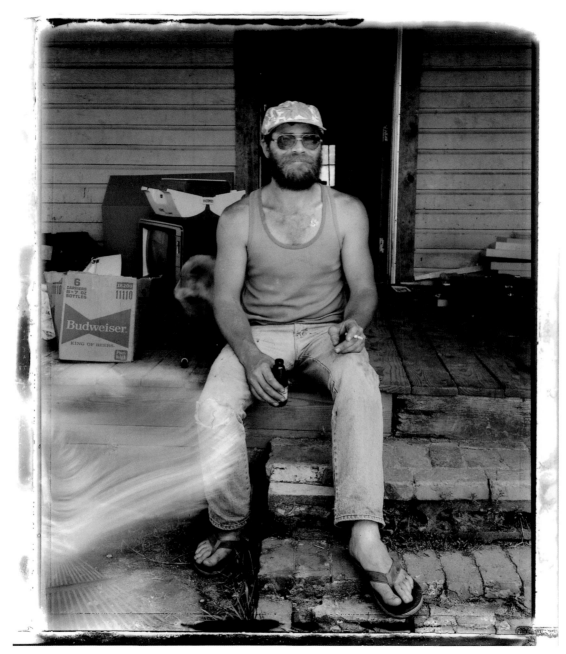

Mickey ○ 1989

I think church made the difference for me more than anything.
Because we were always pegged as the Tooles before anything else. At
the church you were you and it didn't matter. —ALICE

Angela and her sister ○ 1988

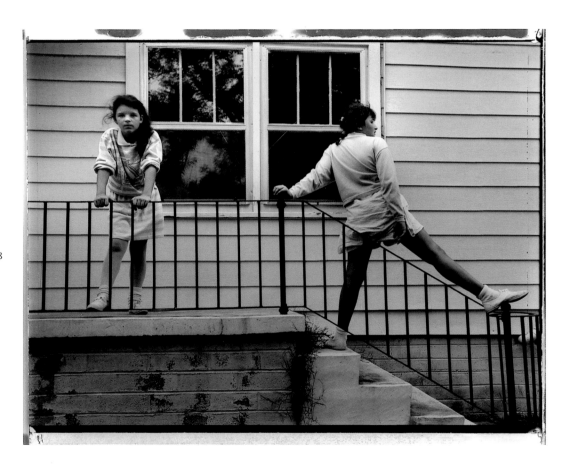

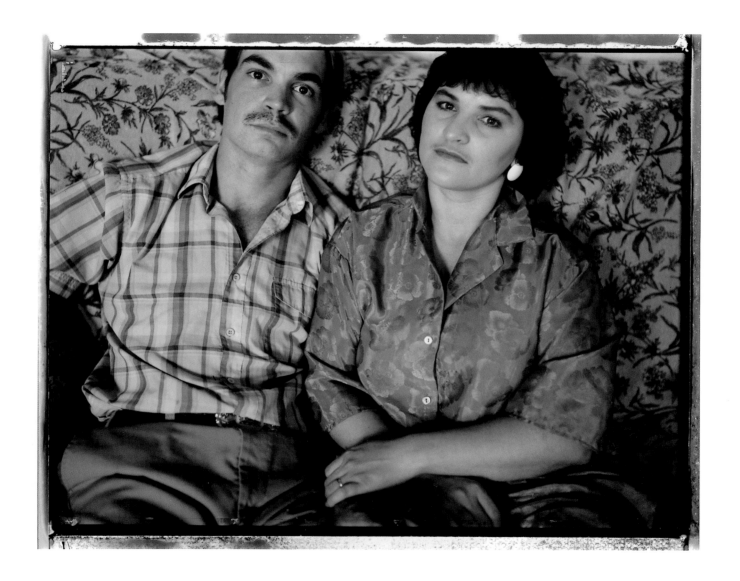

David and Alice, just married ○ 1988

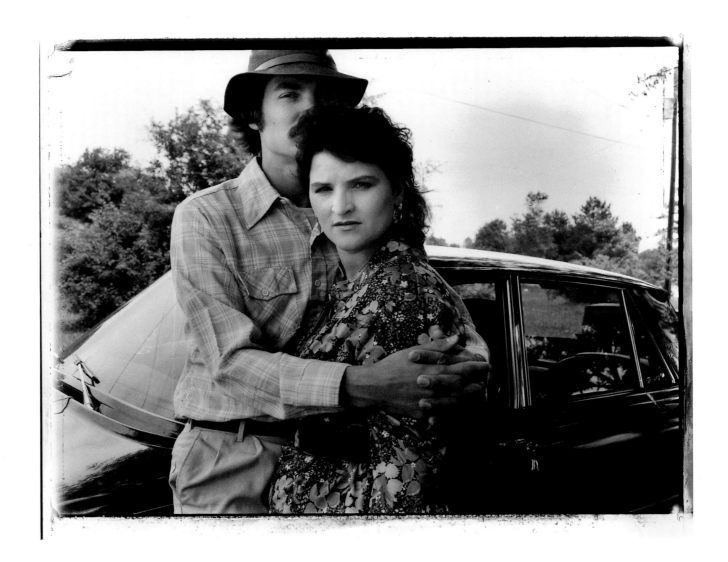

David and Alice ° 1990

ALICE: I was reading in one book that what you learn as a child is what you grow up to be—the attitudes. Even Daddy when he'd be drunk and when we were little, he'd say, "Well, you're nothing, you're nobody, and you're never going to amount to anything." It's whatever you think about. I know it's the church probably more than anything, because I was ten when I started going...
I went because I got hit by a truck when I was ten, and some girls that went to school with my sister were going to church and they pitched in and brought me something for Christmas, and the preacher brought it to the hospital and then when I got out...

VAUGHN: You were in the hospital?

ALICE: Yeah. I was in the hospital for a month. I got hit by a truck. I was in the road and it hit me. I had a broken femur, a broken clavicle, and some bones that were bruised, so I spent a month during Christmas. I was in a cast for two months after I got out and they came to see us and they were having like a youth revival and they came and invited us. So Mary and I went and I was about ten. And then Mickey started going and we all three got baptized but then they kinda grew up and drifted away and stopped church.

VAUGHN: But you stuck with it.

ALICE: Yeah, I did. You can go to church and it doesn't matter where you come from or what you are. And my best friend and I used to sing a lot in church. We used to sing specials. That made you feel that you were worth something.

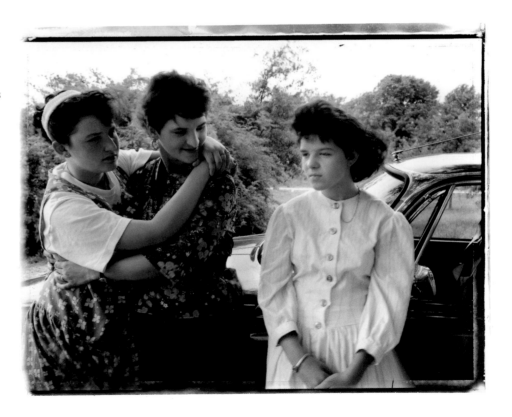

Alice with her daughters ° 1990

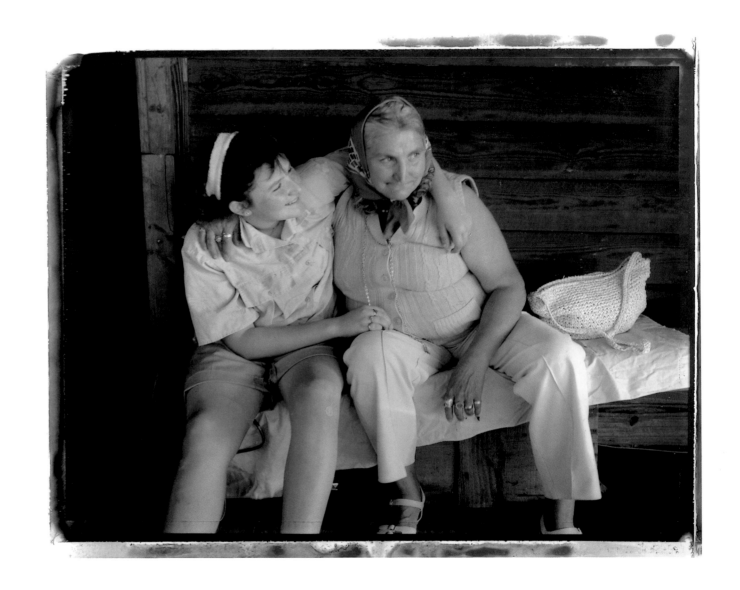

Lois with her granddaughter ○ 1990

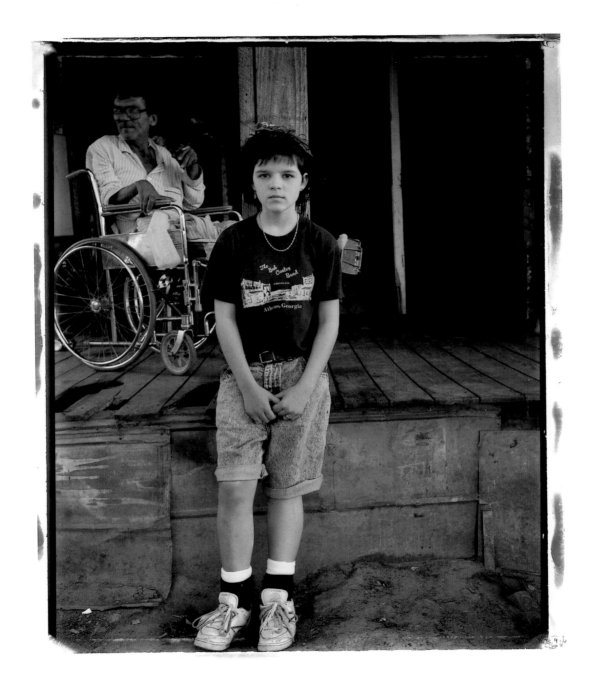

Angela with Kerry's father, Frank ○ 1990

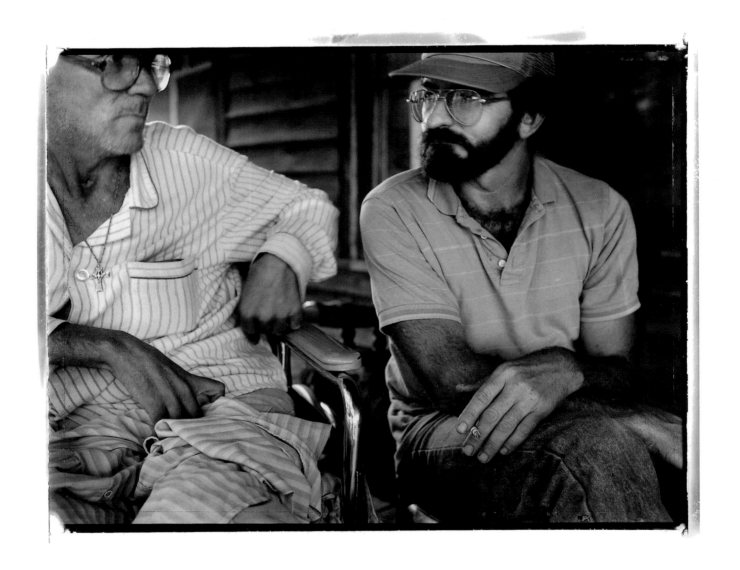

Frank and Jerry ○ 1990

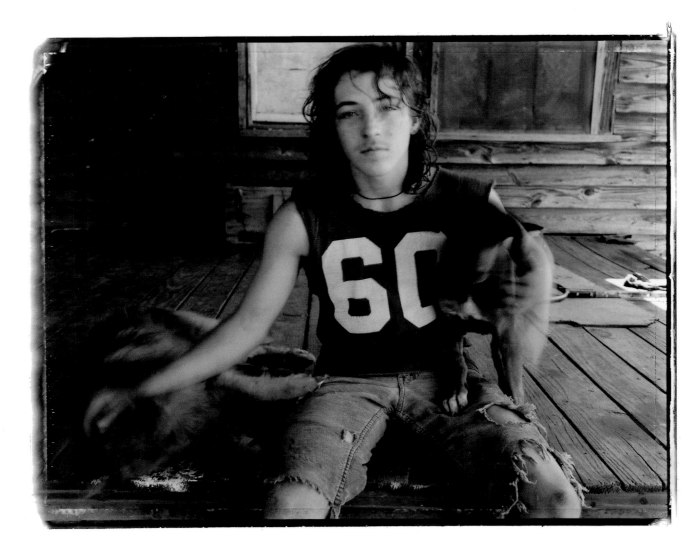

Chris ○ 1990

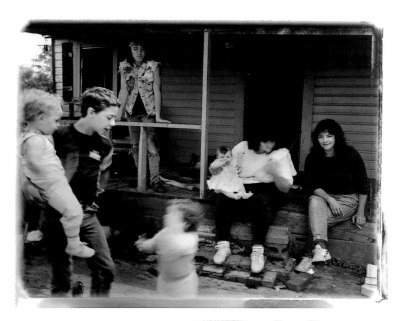

Tina was talking about how hard it was for her and Mike and Tasha
to live out of one room, you know. And I understand
that. I lived out of that room that Lynn's got. That's the
room I had in the winter. But then I felt sorry for Joe
and Kerry because they didn't have any privacy and they
were married and they were in the hall. Me and Justin
moved our little room in the hall, let them have
the bedroom. —MARY

Tina and Mike, Donald and Lynn ○ 1990

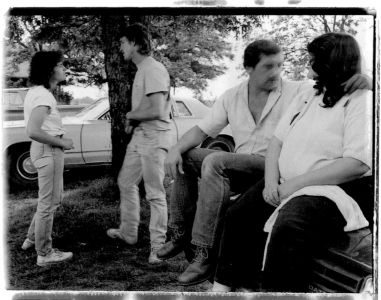

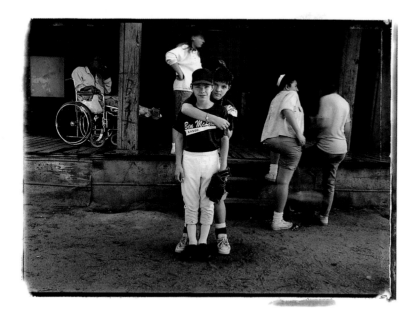

VAUGHN: What will you have to eat on Thanksgiving?
MARY: Turkey and ham, and—I gave Mama some
food stamps last week to buy turkey and ham. Lynn
bought another ham to go with that. Lynn's been
doing the turkey since she got married; right before
she got married she wanted to, but she says she's
not going to cook one this year. She says Mama's
gon' cook it.

I'll probably make a lime congealed salad
and sweet potato soufflé... Tina wants pecans; she's
gonna make pecan pies, I think. Most of the time it's,
like, whatever we got. If we don't have the money,
and a lot of times we don't... None of us has got the
money to go out and buy a bunch of stuff. But, like,
if Jerry's got macaroni and cheese and a can of corn,
he'll bring that. If I've got whatever, I'll bring that.
But by the time everybody brings enough of whatever,
then there's plenty there.

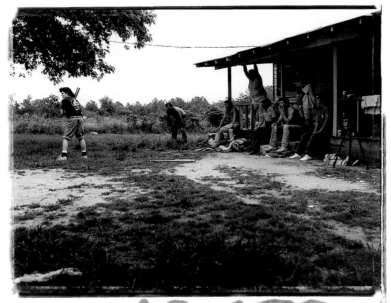

Angela at bat, Lynn's house ∘ 1990

Mary with Justin ∘ 1990

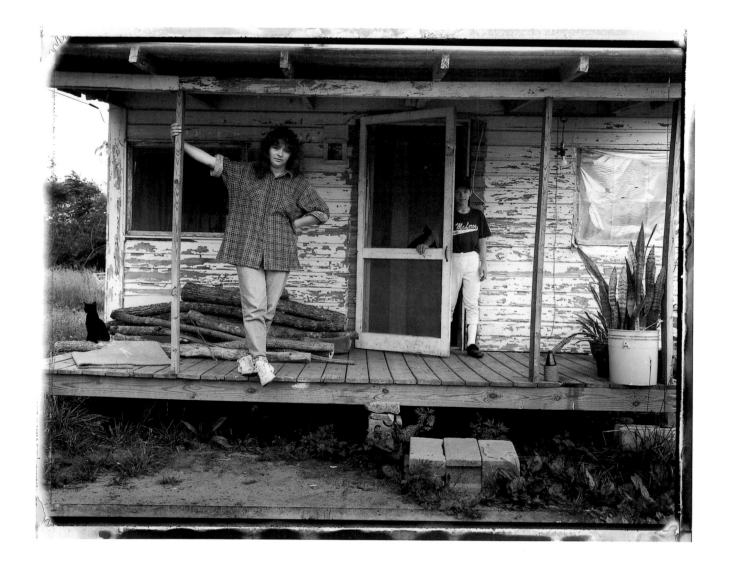

Let's live in heaven
and be together for eternity.
Let's love the world away
and make it our destiny.

Let's tangle our hearts
and combine our dreams.
And live our fantasies
above all means.

Let's let passion conquer
bleeding hearts.
And let the earth
be torn apart.

Let's live in solitude
from the rest.
Let's love each other
with our best.

Together always
forever our ways.

TINA ○ 1986

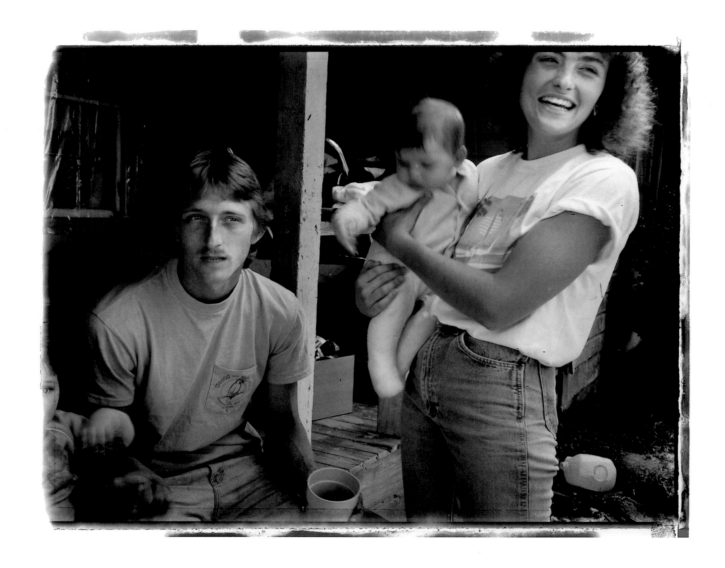

Mike and Tina, with nieces Nichole and Courteney ∘ 1990

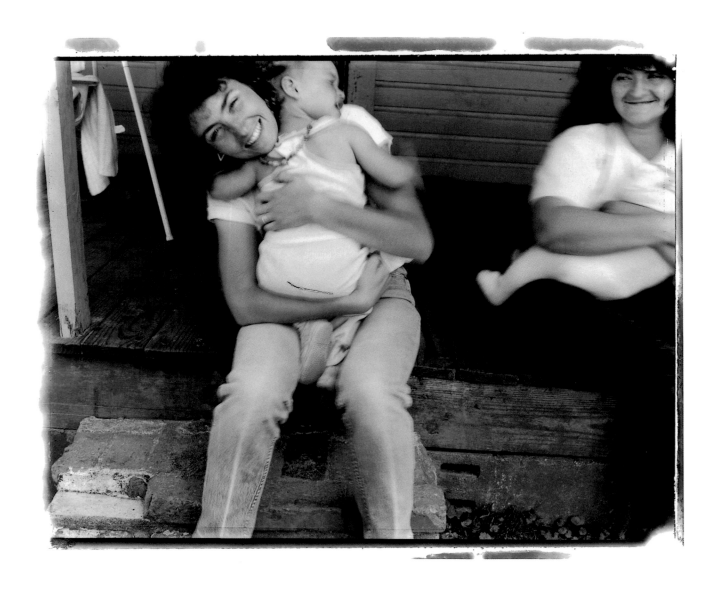

Tina, Tasha, and Lynn ○ 1990

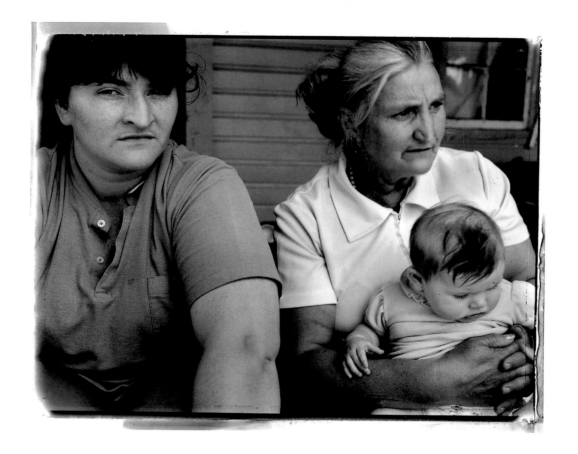

Lynn with Lois and Courteney ∘ 1990

I've had some pretty rich friends, you know, and they say, "I'd give it up any day just to have brothers and sisters like yours." People always tell me stuff like that.

I guess we're all we got. Daddy used to tell us our friends would come and go but your family's always gonna be there. —TINA

THE MARRIAGE ∘ TINA ∘ 1988

I'm sitting here all alone,
he's in the other room.
He's fast asleep,
and I'm full of gloom.

It started out so perfect,
I loved him for a long time.
I woke up one morning,
and he was there beside me, he was all mine.

Now we go to work each morning,
and we go to bed each night.
We seem to be losing faith
it's like our hearts are in a fight.

We're together, but we're apart,
I just don't understand it.
I think love is dying in our hearts
and I can't accept that.

He's not the perfect husband,
I'm far from the perfect wife.
We both try, but still
it's like we live different lives.

We don't understand one another,
we don't talk anymore.
I just don't know what to do,
and how to see it through.

I don't believe he cares,
at least not like he used to,
but after all we've been through
he still says I love you.

He'll stay out late tomorrow,
all I'll do is nag.
He says I'm drowning in my own sorrow.
I guess I am a drag.

I wish we could stop this merry-go-round
and start from anew
take time for one another
and save a love that's true.

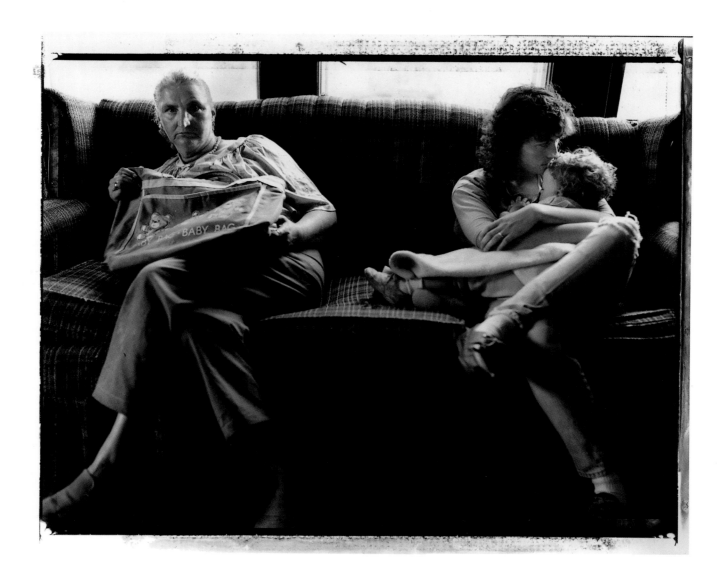

Lois, Tina, and Tasha ∘ 1990

Tasha and Tina ∘ 1990

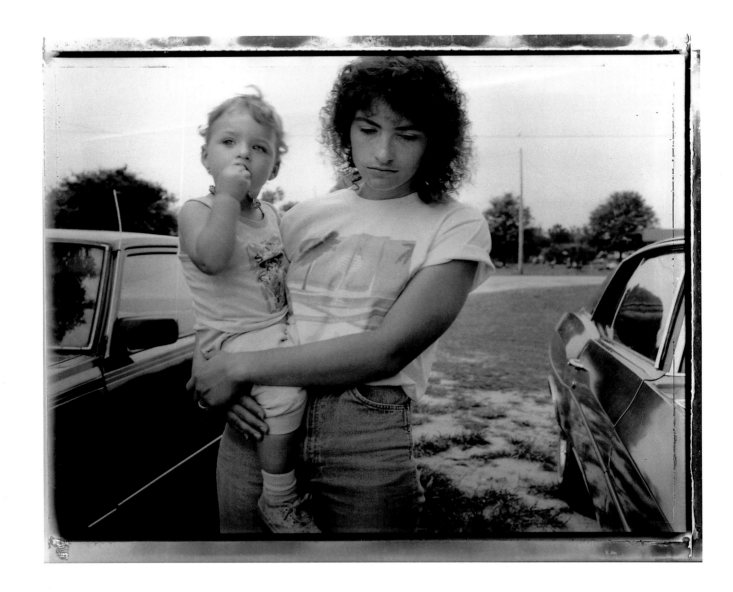

Here we go again,
it's another round for me and him.
It's not as bad as it used to be,
but now he's gone and it's just me.

It starts with a few words
here and there
angry hearts prepared to tear,
and words of hurt we must bare.

TINA ○ 1990

Our anger goes too far,
words turn to screams.
He pushes me down, and stomps on my pride,
as tears start to stream.

I feel helpless and don't know what to do,
I tell him to leave, that we are through.
Then I sit alone and feel sorry for myself,
while he's out drinking and forgetting everything else.

He'll come home in a day or two,
and ask me if my fussing is through.
He'll ask me what I want to do,
I'll say I don't care, it's up to you.

Then we go for it again,
back into the same ole thing.
But deep down, I still can't forgive him,
and neither of us will take the blame.

I love him too much, to lose him,
but the hurt isn't worth it.
I'm confused and I want to believe him,
but the bruises just don't help out.

I try to tell him this,
He just says I'm rubbing it in.
It lingers on and on,
until once again he's gone.

Here we go again.
It's another round for me and him.
We're both too dumb to see,
that no one really wins, not him, not me.

Lois, Joe, and Kerry's house ○ 1990

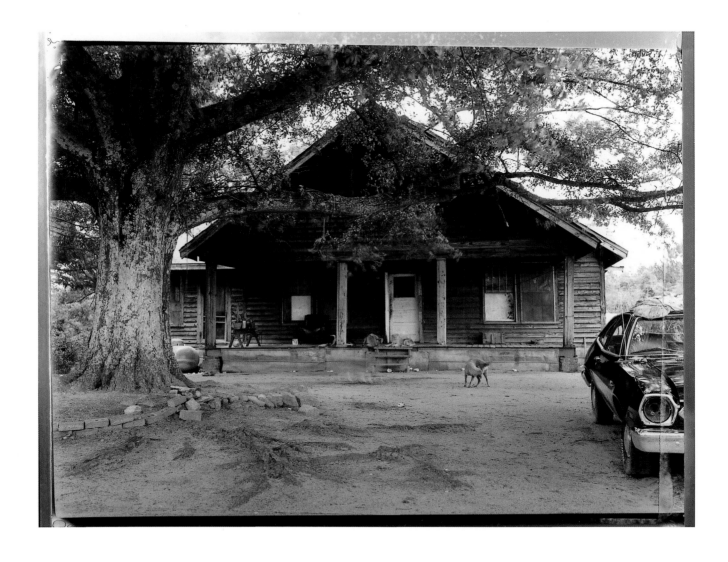

Carpentering and brick laying used to be an art. You go in and you stayed till the job was finished. They did everything. Now you've got sheet rock man, insulation man, wiring man, finishers, trim men. Somebody else to do shingle. Productions, on down the line. It took a lot out of the job, too, I think.

That one guy, me and him, we built all those columns at that mall, every one of 'em. There were nothing but beams back there, and we had to form it up and put metal studs in there and put plywood on it and they just glued the marble to the plywood. I enjoyed that.

I like working in maintenance. I had a friend, he ran maintenance on Villa East and West apartments. He was the maintenance man over there, and he got me a job helping him. Then I worked for him, with him maybe four months.

I remember I had twenty-eight refrigerators out... I fixed twenty-four of 'em. They bought four refrigerators. Out of twenty-eight they bought four new ones. I went over there to Athens Tech and got in touch with Harvey Stanfield. He runs a heating and air conditioning department. I met him up there at Harris Appliances one day and asked him what I was doing to these refrigerators that was wrong. That was interesting. I learned how heating and air conditioning worked, and I learned how to work on furnaces and stoves.

I'll tackle anything. Daddy was always telling me to go for it. If I'm not going to school, go to work. Don't be no bum. So I've been working. I guess me and Suszan would've had a lot more but we had the trouble we did, and it just seemed like everything we had just got away from us... I don't guess there's no hard feelings. We finally realized that you're only gonna have what you work for. So you can't blame it on someone else. What does that old song say? The hardest thing about growing up is realizing that all the mistakes were your own. So... that's about it. Maybe one day you'll come down here and I'll have a big fancy house on a hill. —MICKEY

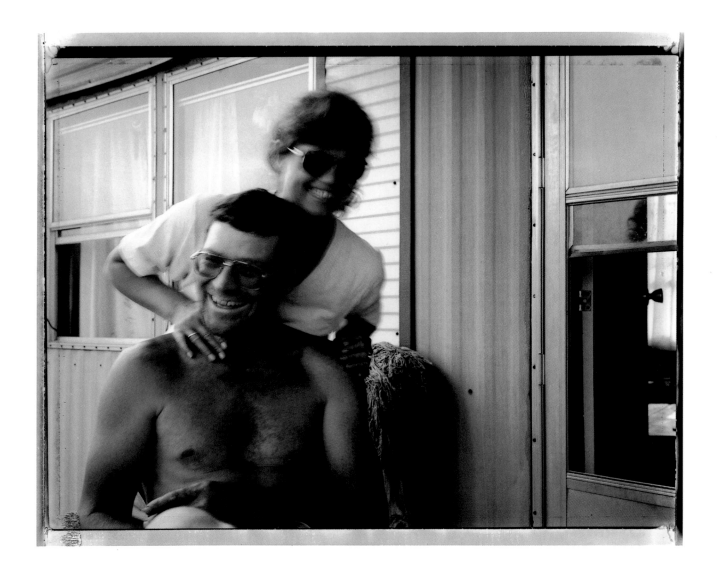

Mickey and Suszan ○ 1991

The cat's on the table,
and the birds are in the air.
And I wonder
What am I doing here?

The screen's off the window,
and the fish tank's full of milk.
And I wonder
How'd I ever get here?

The couch is on blocks,
the carpet looks rough.
And I wonder
Why is it always so tough?

My nose is itching,
someone's on the way.
Well it's all too bad,
they can't stay.

The phone's been ringing for someone else,
and the neighbor's radio sure is loud.
And I wonder
Why I'm so damn proud.

It's just another Bogart Morning.
And I'm just sitting around.

BOGART MORNING ○ TINA ○ 1993

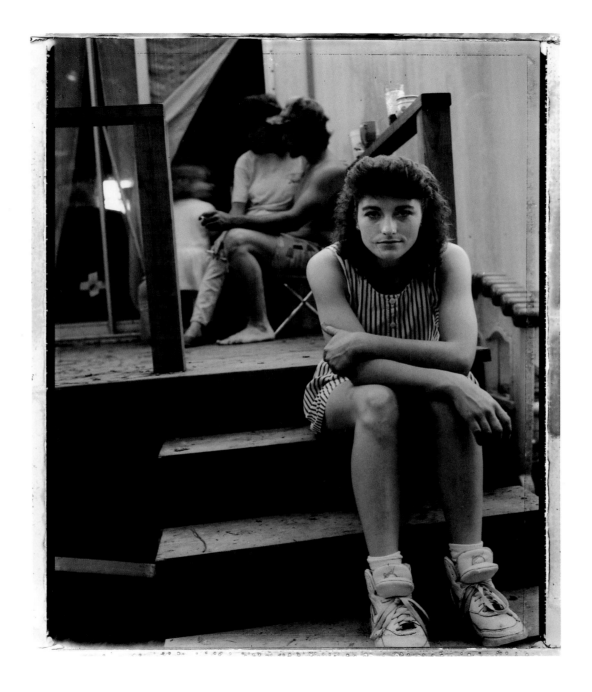

Tina with Tasha, Kerry, and Joe ○ 1991

Dear Vaughn,

I know the day you came over to the house we didn't really have a chance to sit and talk. But there was something sorta bugging me. I wanted you to know that I am not a quitter. It may not have worked out for me as a bookkeeper for Barrons, but I liked doing books and I was pretty good... It's just I know you think a lot of me and I don't want you to feel disappointed. I really feel an office job is just too stressful for me. I really can't get over how stressful and underpaid the field is. It's ridiculous. I want a job I can be happy with and one I can be satisfied with and that just wasn't it. I like the outside. I feel so free, so alive. I love to hear the birds sing and the sky is so beautiful. I love to just look at the clouds and the trees and the grass and open fields. I love riding in the country. It's just so peaceful, so undisturbed and natural. I really feel good when walking down a dirt road and the wind blowing softly. And to watch the water flow over a rocky shoal. I guess I'm getting carried away. I can't help it. It's funny the things that get people all riled up...

I was over at Alice's the other day, and we were sitting talking and I don't know, it was strange. We were talking about making it in life. Vaughn, maybe I'm just not right in the head or something. But here Alice wants a nice career, house, and a lot of the finer things in life. I really don't care for that. I want nice stuff too but I want to be happy and I don't want to have to work so hard to get things that I lose my peace of mind. I want for my kids to be happy and to have the things they need but I don't want a fancy house and all. And I really mean this. I want a nice ole country house. Maybe even a farm. I have a nice car so now all I need is to get my truck running. I have a '65 Chevy. I love my ole truck. Maybe I'm just country as hell. I don't know but I know what makes me happy... I want to spend as much time with Tasha as I can and maybe even grow up with her. No I don't want to grow up.

I think if I could write songs I'd be rich. Or if our family could sing. A big close family doesn't come along every day. And I think through good times and bad we all love each other and that came from Mama and Daddy. We may not have been rich but we knew Mama loved us and we knew Daddy loved us and that was worth more than all the money in the world. I'm really sorry I got carried away. It's just that I get all caught up in writing and go on and on.

Anyway, I am gonna relax for a change and enjoy this summer. Maybe spend a lot of time at the river. I have a whole life ahead of me, why not enjoy it. Tasha is like a flower that blossoms every day.

Love,
Tina

TINA ○ MAY 30, 1990

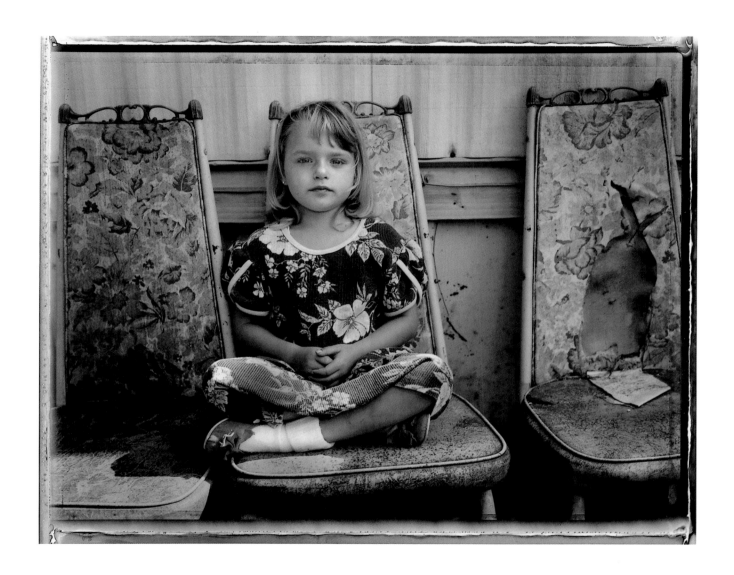

Tasha, three years old ○ 1992

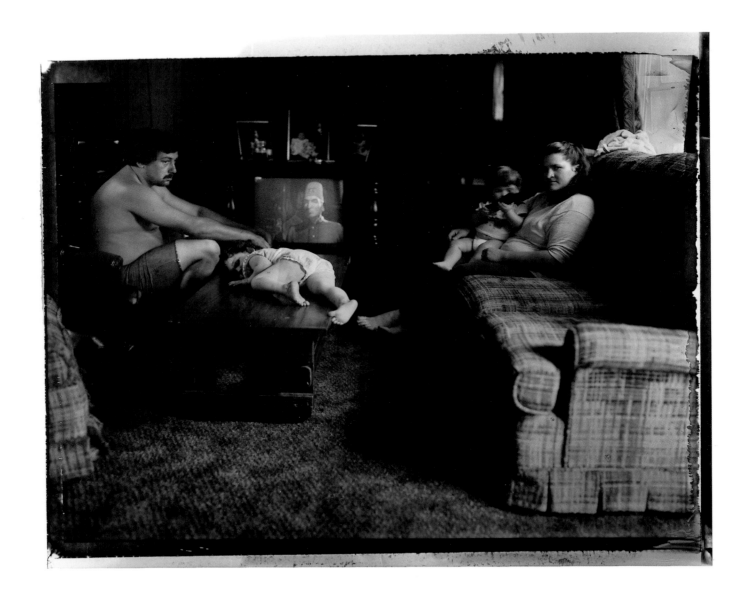

Donald, Nichole, Courteney, and Lynn ○ 1991

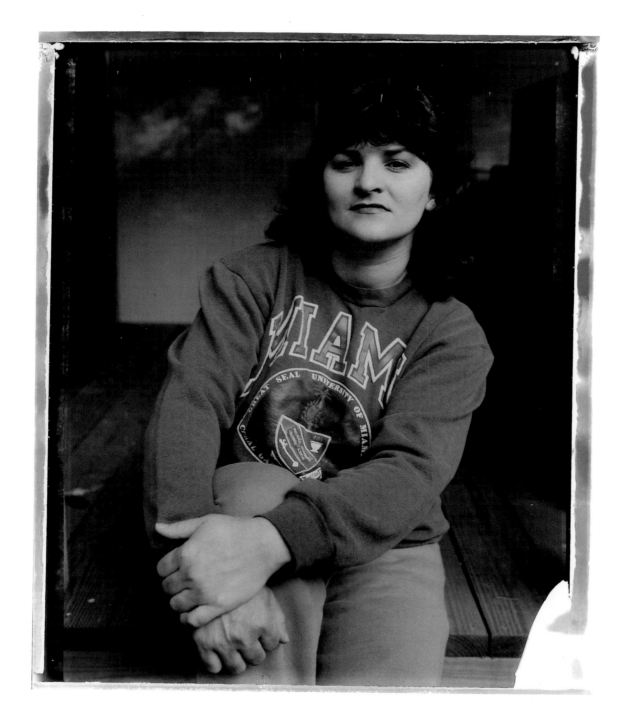

Alice ◦ 1992

Alice and Angela ◦ 1993

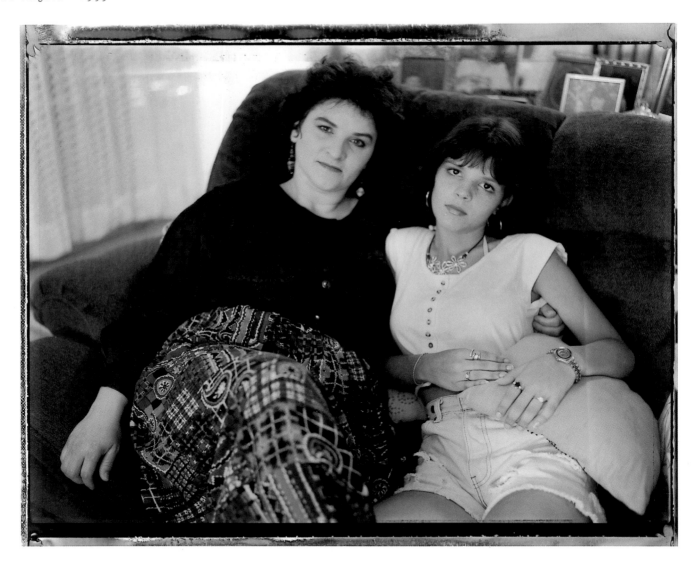

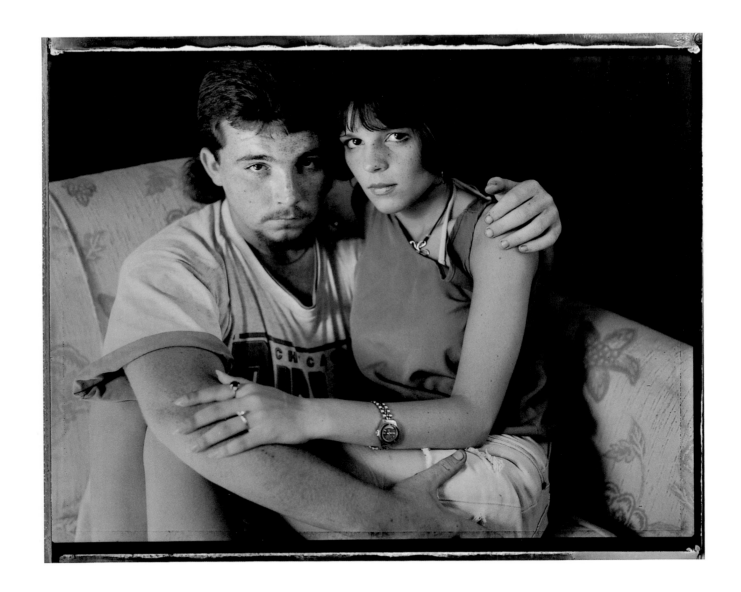

Shane and Angela ◦ 1993

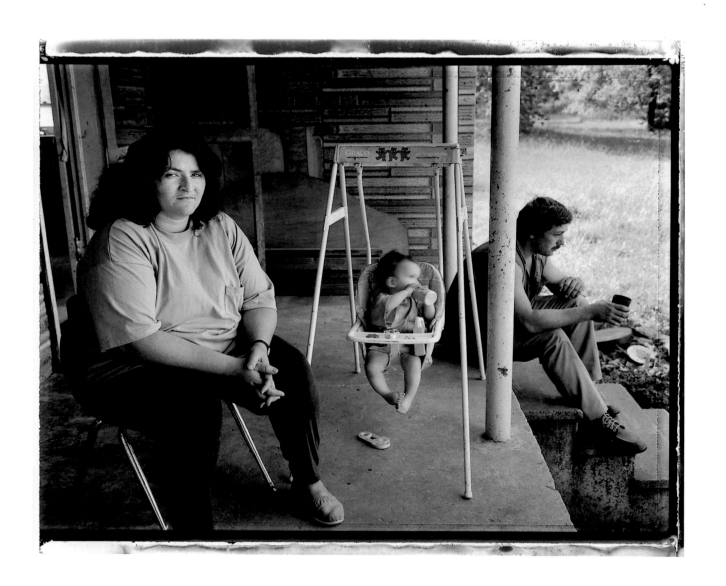

Lynn, Ashlynn, and Donald ○ 1993

LYNN: It is nice sitting out here in the summertime
when all the flowers are blooming, and all these
trees have flowers on them—all of 'em do, except,
I think, that one in the middle.

KERRY: I think that does, too. Even our fig trees have
flowers on them.

TINA: I bet my flowers will die in the wintertime,
won't they?

LYNN: Not if it's the Morning Dew. They stay alive all
winter long.

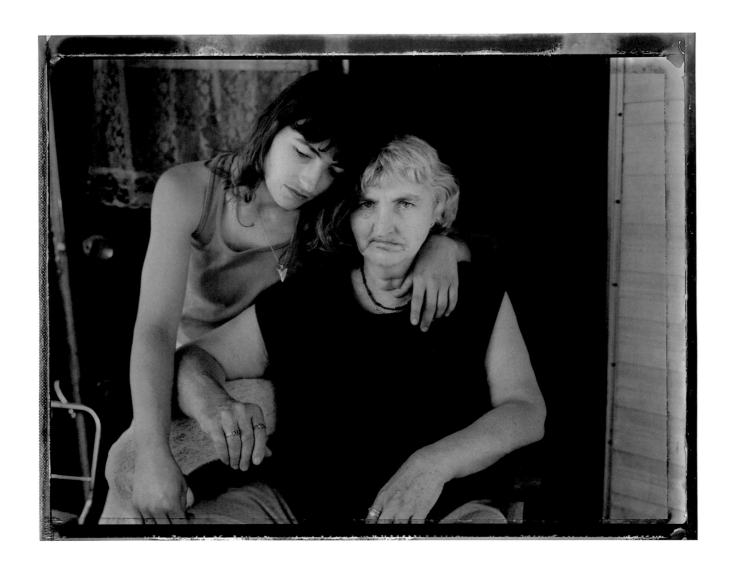

Tina and Lois ○ 1993

TINA ○ 1993

*I walk alone
down a long dirt road
I look around
but everything looks so old.*

*I think I've been here
many many times
but it seems so different
and I see no familiar signs.*

*I feel a chilly wind
as the air grows cold
I try to shake it off
but it's just too bold.*

*I hear the thunder
somewhere in the distance
I walk a little slower
no reason for me to resist it.*

*I see the clouds
moving faster and turning gray.
I'm not touched
I don't care if the storm comes my way.*

*The rocks hurt my feet
cause I don't wear shoes.
I guess this old road is like me.
It's used to being used.*

*I walk on and on
not knowing what
led me to walk down
this old road.*

*All I know is that
I'm used to walking alone.*

TINA ○ 1990

to Natasha Dawn Casper

Please forgive me darling,
for what I've done to you.
This plan of family life,
I had fell through.

I'm not just losing him,
but also a part of you.
I'm losing my hold on life,
now what can I do?

I look into your eyes,
and I feel so ashamed.
Your daddy is leaving you,
and he and I are to blame.

This feeling just won't go away,
that your heart will break.
So please forgive me darling,
for the choice I had to make.

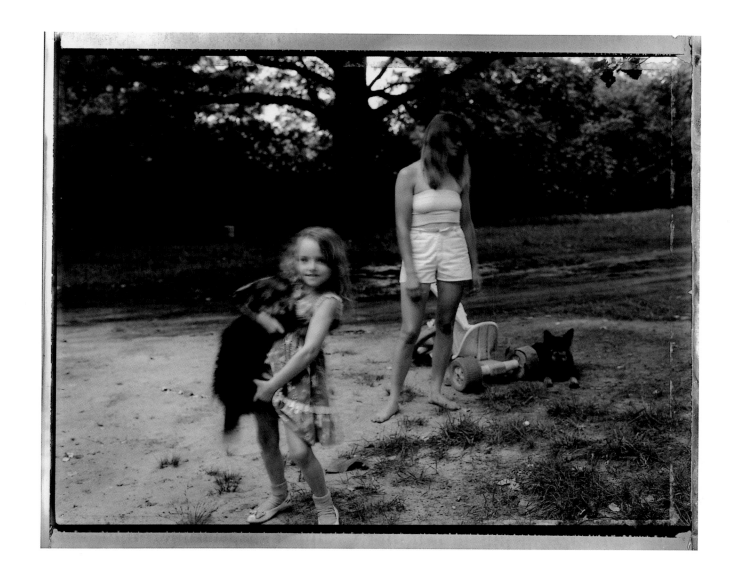

Tasha and Tina ○ 1994

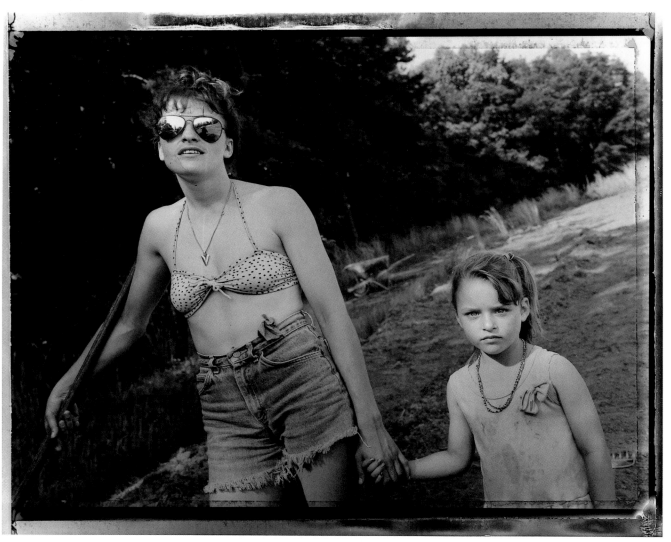

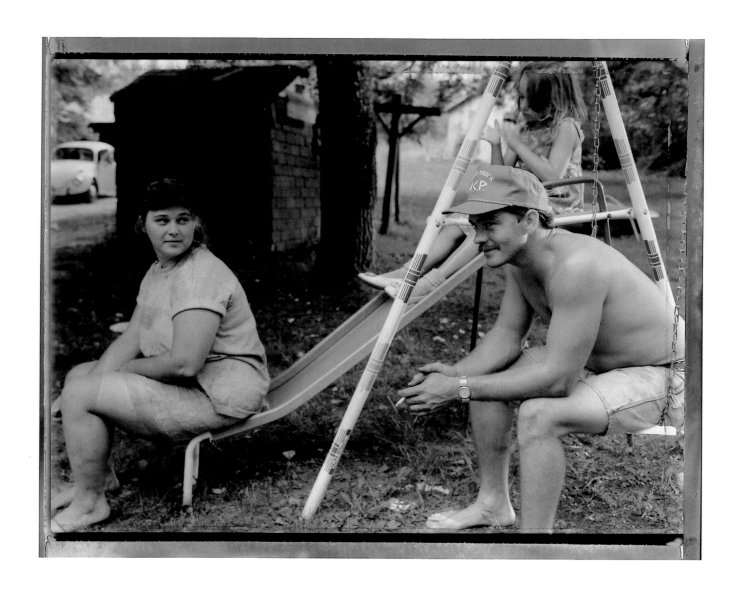

Beth and Joe with Tasha ○ 1994

Well last night I erased your message
and I didn't return you a call
sorry about that, baby,
but life goes on after all.

It's been about five good years now
since you slept in my bed
sorry about that, baby,
but thoughts of you have left my head.

You know what you did, boy
I can't change the way I feel
sorry about that, baby,
but I don't think I ever will.

I did my part
I gave my heart
but you just run away
sorry about that, baby.
It's too late for you to stay.

TINA ○ 1996

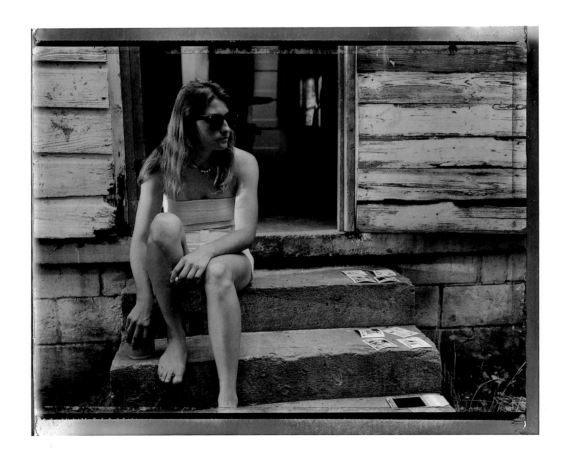

Tina ○ 1994

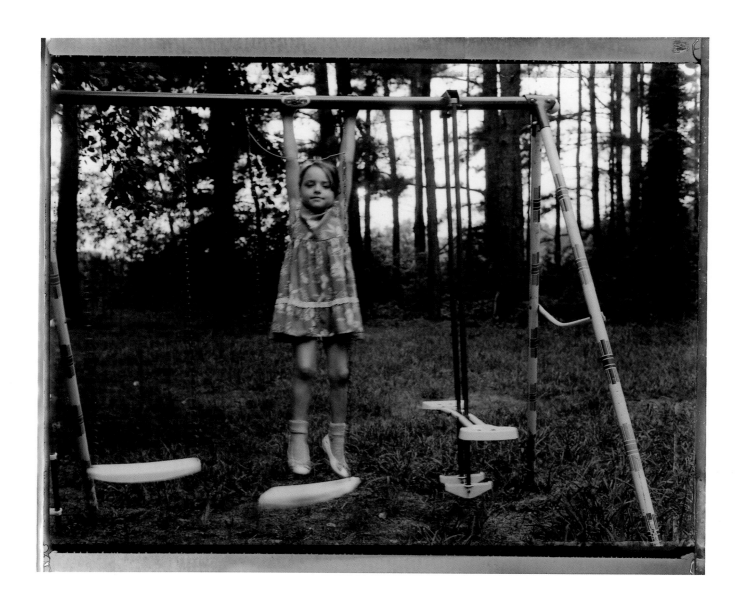

Tasha ○ 1994

Mary ∘ 1994

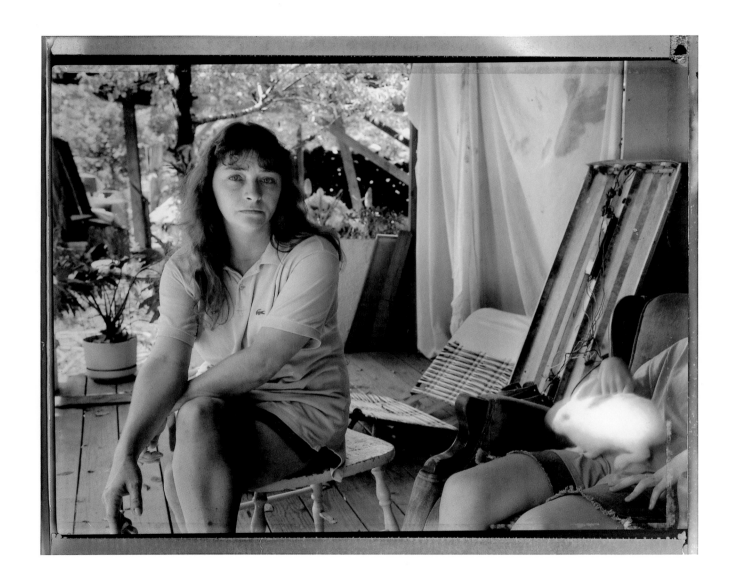

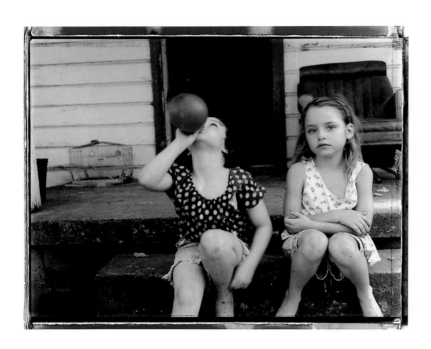 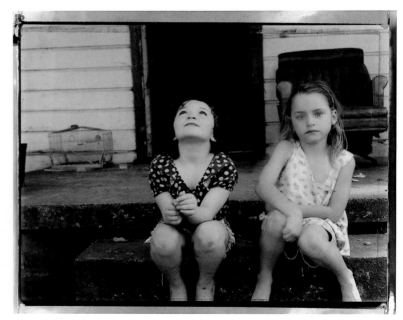

Nichole and Tasha ○ 1994

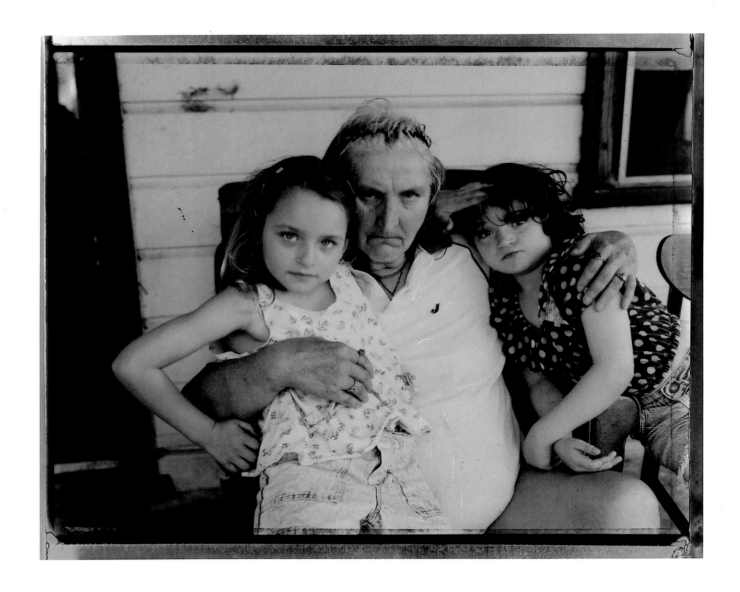

Lois with Tasha and Nichole ○ 1994

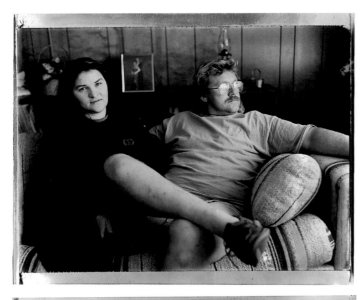

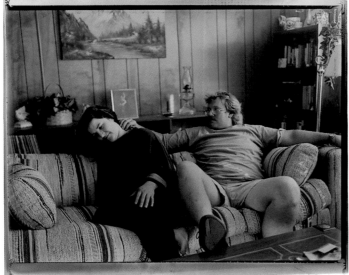

We went in to the church, and I saw David, the pastor, and I thought, Oh, this must be a good church. He's an evangelist. And they were singing and dancing and stuff, and me and Angela got up and started clapping our hands and stuff, and we were singing. I liked it. I really liked it. Then I cried the whole service. I was like, Good Lord, and they didn't know why I was crying. I cried the whole service. He was talking about if you had a husband who wouldn't be your husband, God would be your husband, and all this kind of stuff. And so, anyway, at the end of the service, he said that he wanted all the mothers to come down front and he wanted to pray for them. So me and Angela went down there and, I mean, the minute we got up there and we stood, I just turned to Angela and I just started bawling. I was bawling, and bawling, and bawling. I couldn't quit crying. I was, like, What in the world is going on here? And I knew it was the pastor and his wife behind us. I just knew it. And they were praying, and I heard her go "brrrrrrrr." And I'm, like, They expect me to believe that's tongues?

You expect me—I mean, this was in mind. I'm thinking, That's tongues; yeah, right! Right, right. But it was good. So that was Mother's Day 1996.

Me and John were separated then; we were still separated then. I got up that Saturday; I was so depressed. I got up three times and went back to bed because I didn't feel good, and I was just real depressed. And I got up, and I started to go back to bed, and I said, No, and I cut on the TV, and Walt Mills was on, and he was singing a song, and then he just stopped. When he finished singing the song, he goes, "Well you know, God just changed my whole format for somebody." He said, "I have no idea who you are, he said, but God just changed the whole format of my show for somebody." And I sat down and I'm, like, Lord are you talking to me? And he started talking, and

he said, "You used to serve the Lord, you used to be in church, but you know you're not in church now and you're away and God's calling you home." And I was sitting there, and he said the sinner's prayer, and I repeated it. And so, you know, I sent him a letter and wrote this in there and tucked it in and said I had rededicated my life, and that was on Saturday, the 18th.

Then on Sunday morning, the 19th, I got up, and I was getting ready to go to church, and I was listening to Earl Park, the preacher at Chapel Hill in Atlanta—and I really like him—and he was talking about God's an all-consuming fire: "Do you want that fire? Do you want fresh fire from on High?" I was, like, Yes, yes, yes! Well I got to church that morning, and it was really good. At the end of the service, I went forward to the altar, and the pastor's wife came over and she said, "Are you saved?" And I said, "Yes." She goes, "Have you been baptized?" I said, "Yeah." She said, "Do you have baptism of the Holy Ghost?" I said, "No." She said, "Do you want it?" I said, "That's why I'm here."

So she went and got the pastor, and he came over, and so she put her hand like right here on my stomach and he put his head on my forehead, and he said, "Open your mouth." And he said, "Just keep your mouth open and whatever comes out, let it come out; just don't talk in English." And they started praying for me, and I started doing that brrrrr and some other stuff, and I'm, like, Whoa! Okay, and Cindy goes, "You got it, you got it, you got it!" And she said, "You may be praying in tongues during the day, you might catch yourself." So anyway, when I left, and—you know, when the Holy Spirit speaks to you, you know, in your spirit—so it's like that thought, and things come into your heart—not an audible voice,

but anyway, the Lord said, Go get your husband and bring him home; I'll work on him and I'll work on you.

I had to work that night; I couldn't get out of working, but I tried to find John and I finally called him that night. It was about 10:15 because he'd been mad at me and just wouldn't return my phone calls. And I told him, I said, "Well, I got baptism of the Holy Ghost at church, and the Spirit spoke and said to go get you and bring you home and that He'd work on you and He'd work on me."

So he's, like, Well, okay, I'll come get you and we'll go to dinner tomorrow and we'll talk about stuff. So Monday night he came and got me and we went to dinner. We'd had dinner, and we were sitting out there in the truck, and he was sitting there, and he was talking to me about stuff, and he was, like, Well, since we didn't really get to talk tonight I'll come over tomorrow and we'll sit down and we'll lay all the cards out on the table and we'll discuss everything, and da, da, da. And I'm, like, I've got to work tomorrow night, John. That's when I was working part-time at the Golden Pantry before I got back in school, and I was working part-time at the doctor's office. I had three part-time jobs to make ends meet.

So then anyway, he said, Well, I'll come over Wednesday night. And I'm, like, I'm going to church Wednesday night. He said, Well, I'll come Thursday night. I said, I've got to work Thursday. He goes, Well, I'll come Friday night. I said, John there's no laying the cards out on the table, and da, da, da. The Lord said to go get you and bring you home and He'll work on me and He'll work on you, so come home.

He's, like, Well, what about tonight?
I said, Just go get your stuff and come back. —ALICE

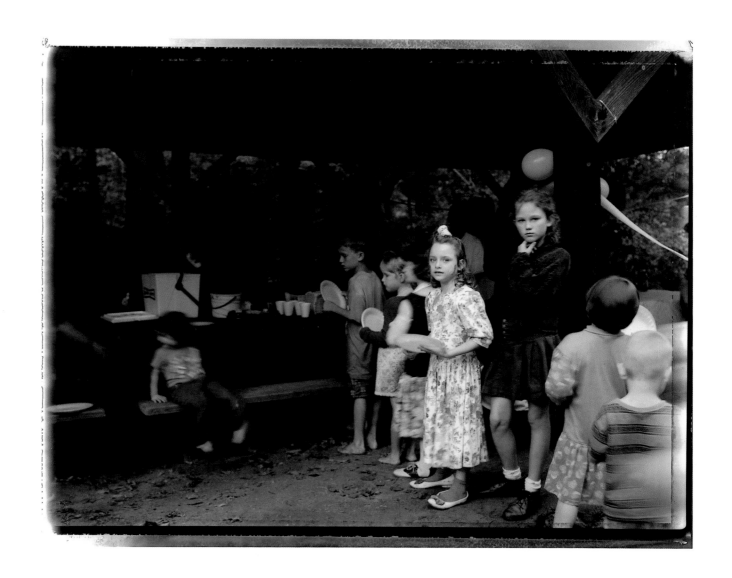

Tasha at her seventh birthday party ∘ 1995

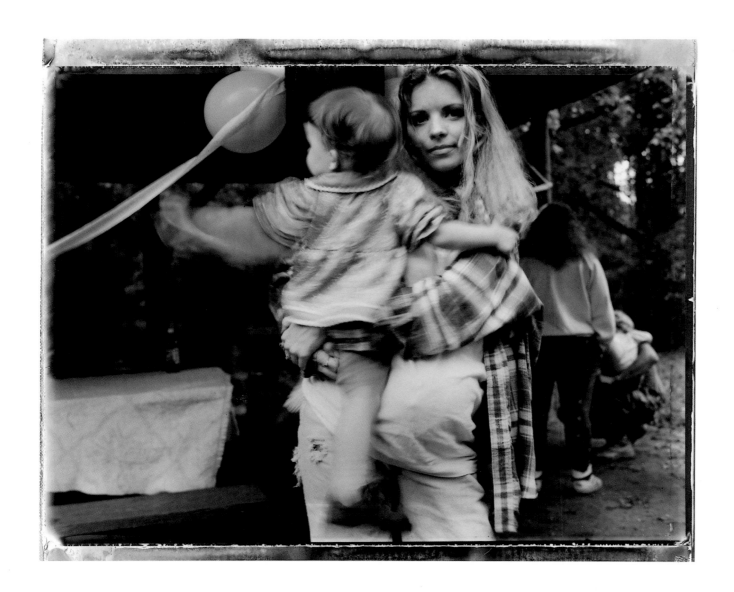

Angela with Chellsey ○ 1995

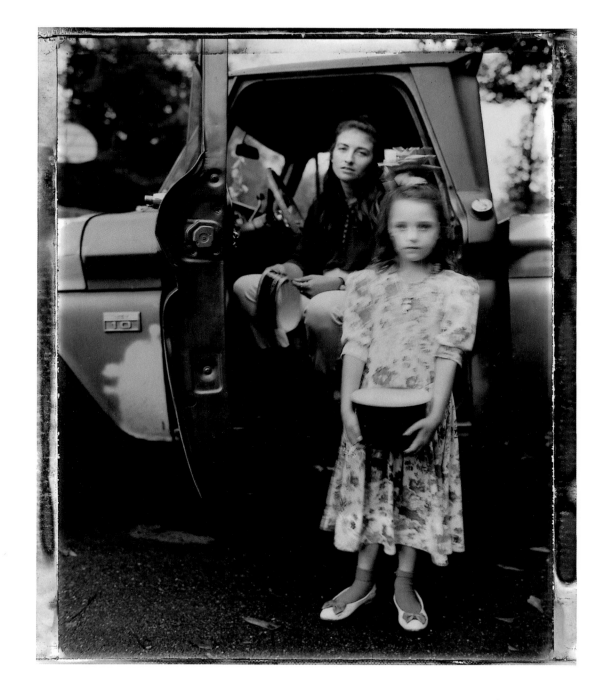

Tasha ∘ 1995

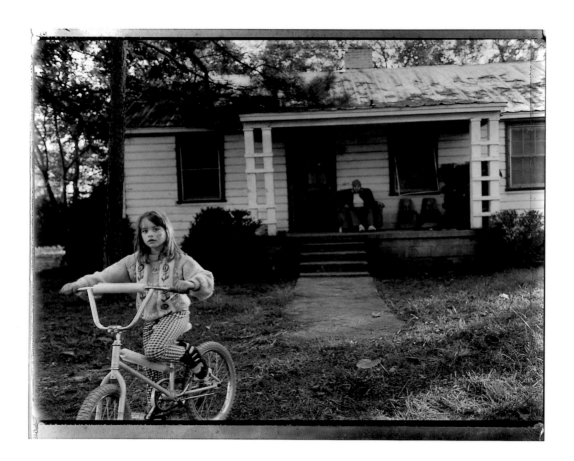

When an angel breaks her wing
They say the birds all stop around her and sing
Sometimes we can't help everything
Like when an angel breaks her wing.

She flies through the here and now
Handles it all sometimes, somehow
She's alone and so in control
When and where she is, we never know

We live our lives from day to day
None of us knows how long we'll stay
The wind can make us stray
But once in a while we have help along the way

But when an angel breaks a wing
They say all the birds stop around her and sing
Sometimes we can't help everything
Like when an angel breaks a wing.

TINA ∘ 1996

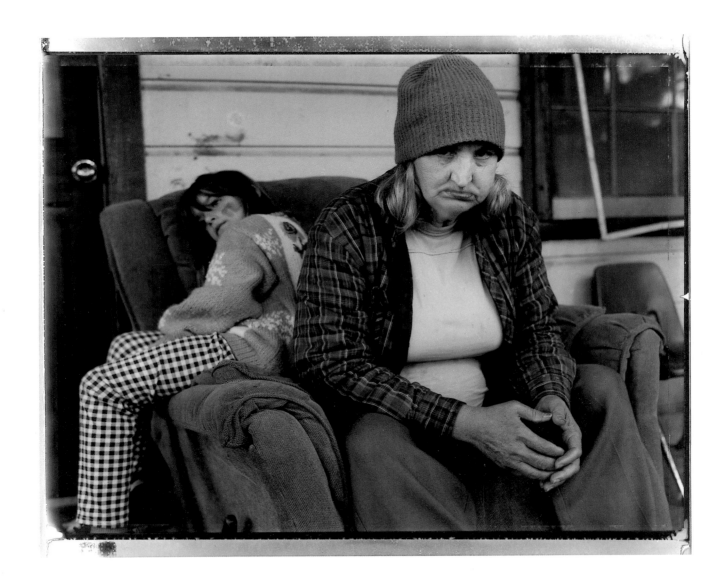

Tasha and Lois ○ 1995

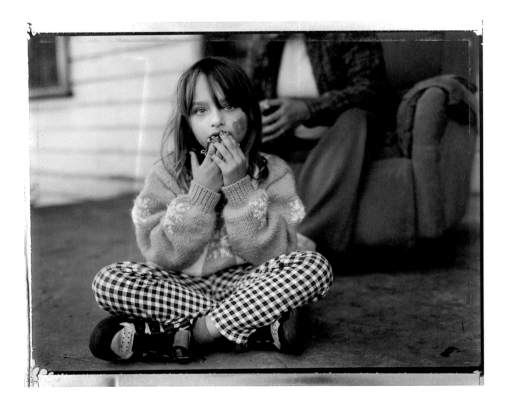

Tasha ∘ 1995

Just at dusk one Sunday evening, Tasha, Lois, and I were on the front porch waiting for Tina to come home from work, and I asked Tasha, "What do you want to be when you grow up?"

She looked at me and answered carefully, pausing between each thought,

> I want to be everything.
> I want to be a lawyer,
> I want to be a cop,
> I want to be a fireman.

Looking up at the fading light, she said,

> I want to be the sky,
> I want to be trees.

> I want to be blue,
> and green,
> and I want to be red.

> I want to be a grandmother.
> I want to be pictures.

—VAUGHN

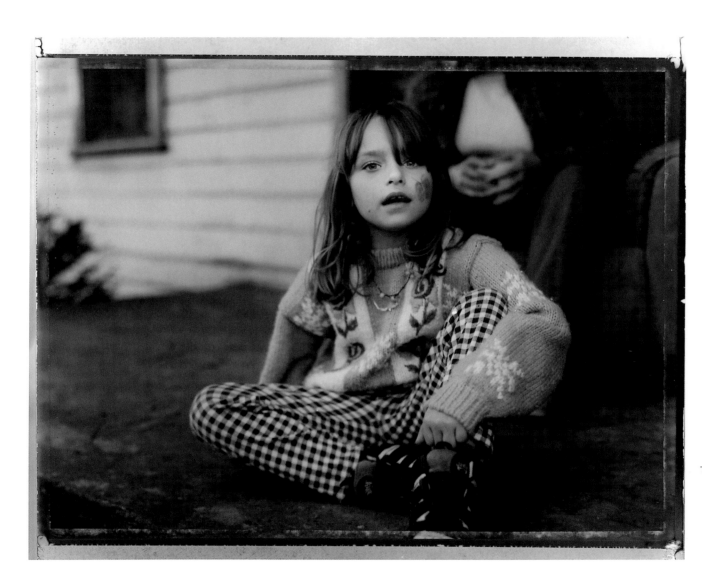

Tasha ○ 1995

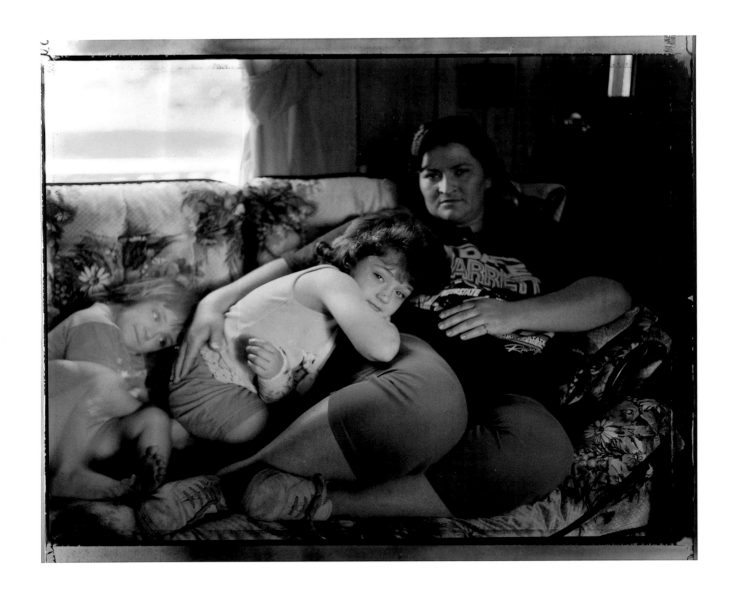

Ashlynn, Nichole, and Lynn ○ 1995

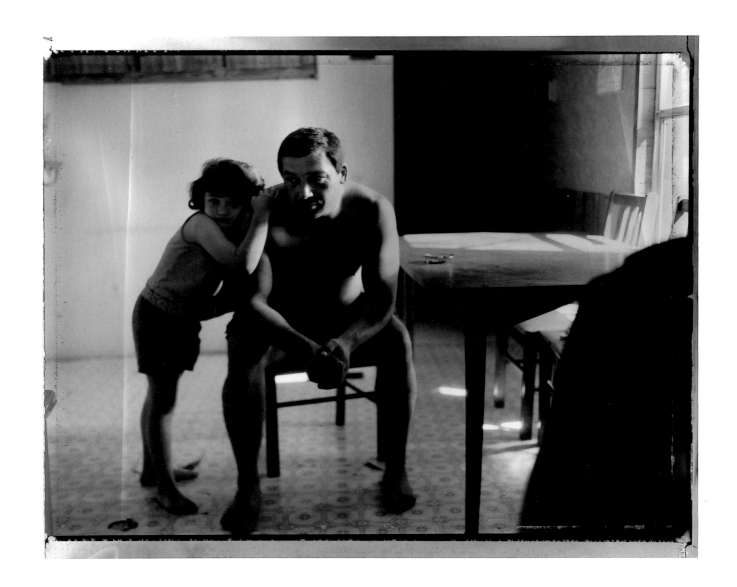

Nichole and Donald ◦ 1995

Lynn, Donald and Courteney ∘ 1995

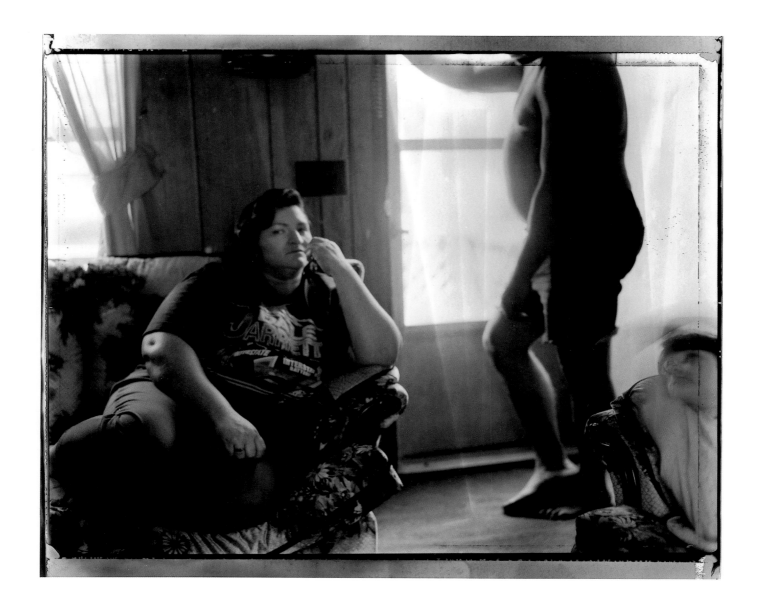

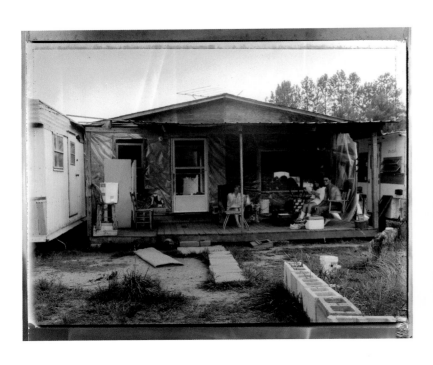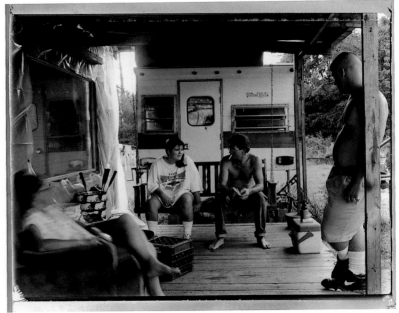

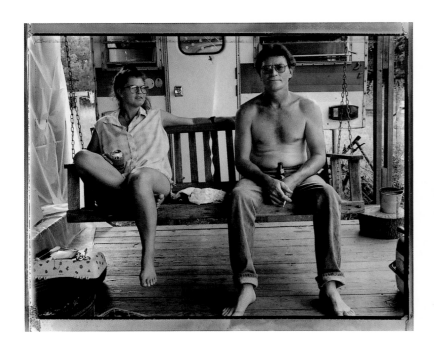 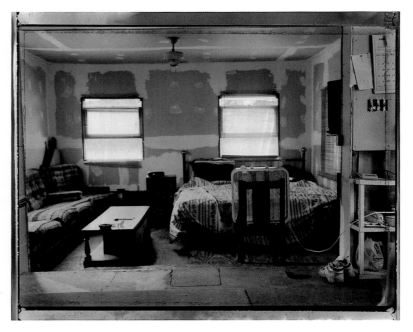

Mickey and Suszan with Michael and Melodie ° 1996

I had never been to Jerry's house before, but with the news that he'd been sober for a year and a half and that he'd gotten married, I decided to go to see him, hoping to meet his wife and, before the sun went down, to make some pictures. I approached along a curving, gently hilly road, past the few landmarks described by Mickey, and found Jerry's house, which was much like others in this rural countryside—a small wood-frame house, in need of a new coat of white paint, with a grass-covered yard and stands of tall trees nearby. The screened front porch appeared to be used for storage, and the doors and windows were closed. I wasn't sure anyone was home. I knocked tentatively.

Jerry politely welcomed me in and offered me some iced tea, which I gratefully accepted. When he sat in a big recliner, no doubt his usual chair, he seemed to be returning to the spot where he had been before I arrived; pointing to the comfortable brown plaid sofa, he invited me to sit down. The living room was painted a soft, easy yellow; the fireplace mantel held photos, including those of his son, daughter, and grandchildren, and a few artfully placed knick-knacks; the only other furniture was a few tables and a console TV. I peeked into the kitchen and glimpsed shiny white wooden cabinets, a table made of white tiles and light wood in the center of the room, and counters perfectly clear except for a couple of decorative canisters. As the light slowly faded in the early evening of a hot summer day, Jerry brought me up to date on the news; it had been several years since I had seen him.

I showed Jerry several of the page-spreads that had been recently designed for this book, and he asked me many questions, all of them pointed and astute: what was my goal, what did I want to show about his family, would I make them look like a bunch of no-good hillbillies? (These are my words; I didn't have my tape recorder with me at the time.) He told me how important it was to him that his father be represented fairly—as a man who was hard-working, who had survived difficult times, who taught his sons needed skills, and who loved them all. We talked quite a while—nearly an hour—before I dared break the flow of our conversation to go to my car to get my tape recorder.

Jerry's new wife Brenda, a pretty woman in her forties with blond curly hair, pulled up a chair next to Jerry and listened carefully and knowingly as he continued to tell me about his father, and then about how he had given up drinking. We talked until well past sunset. —VAUGHN

We get off track, you know. We all got off track for a while. It got to where I was drinking for the sake of drinking. It kept getting worse. And that's what it does; it sneaks up on you. It's just a slow killer, and a big deceiver. You think you're having a good time; the next morning you're sick as a dadblame dog and you don't go to work. And it got to where I lost all self-respect, and people around me didn't respect me for anything. And I spent twenty-five— say fifteen to forty—about twenty-five, twenty-six years just being a rock-bottom drunk. When I drank, I got drunk. I set out to.

I got caught in a trap, and then... I don't know what really brought me out of it. I guess the love of the Lord got me out of it. It was worse all the time. I went through an operation for a hernia, and I was out of work for a long, long time, and I was sitting right here, and I had a good many days to think things out. And I said, Well, I'm not ever going to have a driver's license as long as I drink. If I don't have a driver's license, I'm stuck in this same rut. And, you know, a fella said a long time ago that a rut ain't nothin' but a grave with the ends knocked out of it. It just got down to the point where, you know, either quit this or pack it up and go ahead and die; you're not going nowhere. But anyway, I got to where I'd think about it before I drank. The more I drank, I got where I prayed to get off this mess, and I didn't know how to go about it. Went in AA and stuck in that about three months, and then I just quit going to meetings. And I slipped right back in there drinking again, and the second time around it was just worse. Every time you do it, it's worse and worse.

Then I took a good, long, hard look at my life, and got down on my knees and asked the Lord to take the mess away from me. I put my faith in the Lord above... and never have been very religious.

So December 7 of '94, I drank my last one. That first three or four months was tough. Boy it was tough. There's always a great, great chance that some little something in life will set you off again and start you back drinking. And that's what you've got to be vigilant about every day. You've got to watch yourself every day. And see, the first couple of months, I had to turn my head at a beer sign on a package store. I'd look up at it and turn my head and keep going.

There's some things right now going on that have been in the back of my mind since I was sixteen years old just now coming to fruition, just now coming together. And all that, I think, is because life is turned around. I've done a lot of things. I bought a boat, got my truck fixed. I've got an old truck. I've had a truck out there since 1981, just got it painted this year. I'm kind of proud of that fact. Some people say I'm crazy for keeping it like that. But to me it proves a point. It's a reminder. And I keep that truck sitting out there. The other day me and Brenda went to the lake in it and had a good time. That truck is a reminder to me of what used to be. I've got an old Volkswagen out here that I've had for five years I built out of nothing. It was built with my own two hands. It's something I can pass along down the road one of these days, you know. I don't know what to say. I guess I'm just proud I don't drink. —JERRY

Lois ◦ 1996

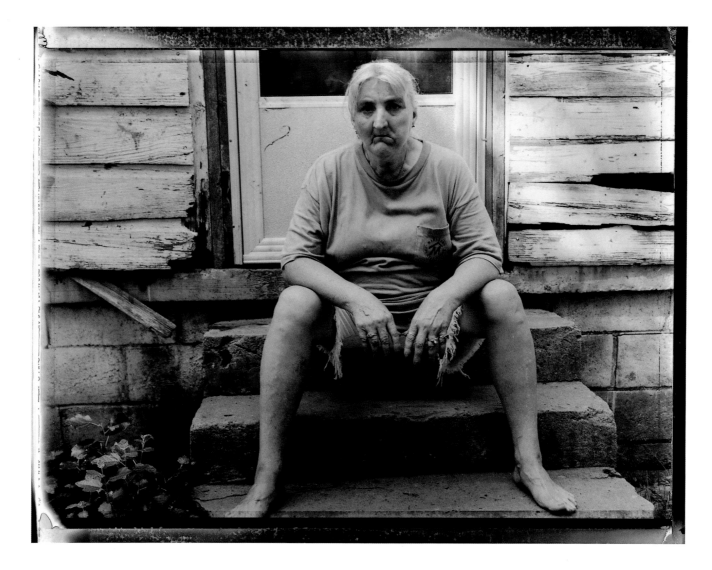

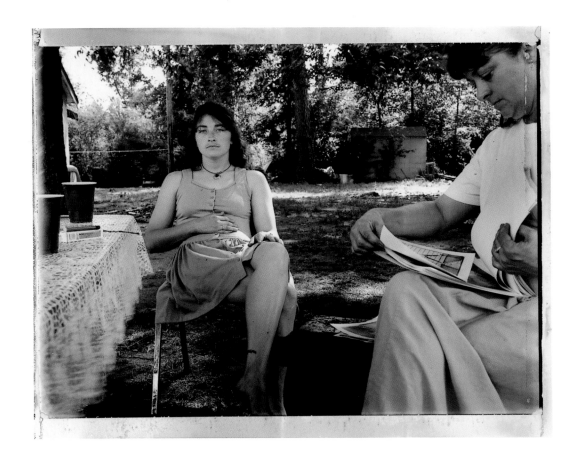

Tina and Mary ∘ 1996

When the sleepless nights are upon you
and that you're still here astounds you
to whom do you look, and what will you find
when blackened clouds surround your mind?

When the stairs only go below

TINA ∘ 1995

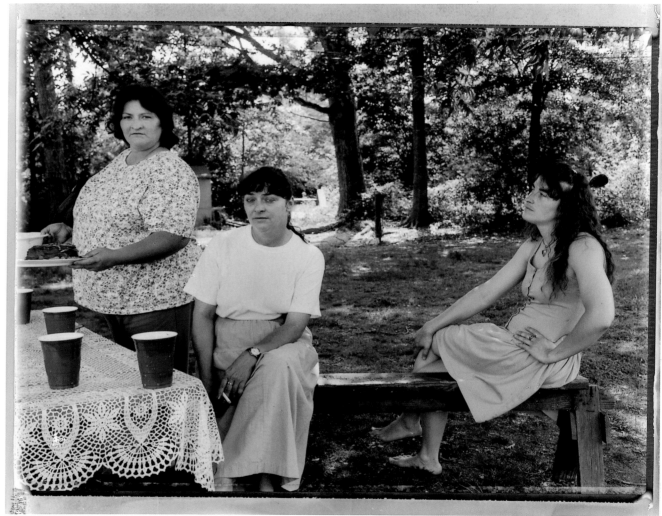

Lynn, Mary, and Tina ○ 1996

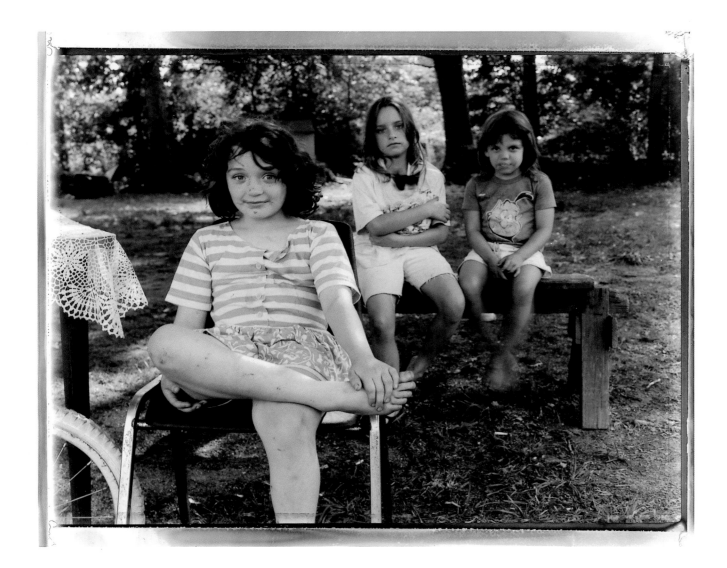

Nichole, Tasha, and Leigha ∘ 1996

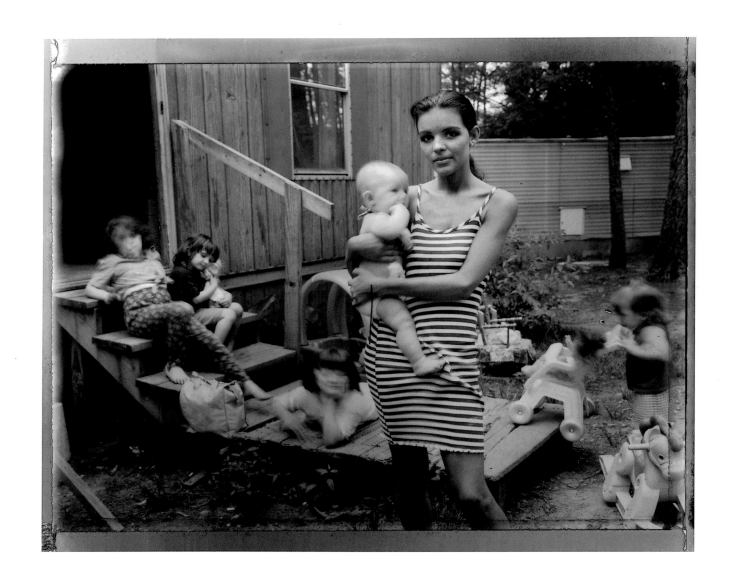

Angela, holding Christin, with Chellsey and Lynn's children ○ 1996

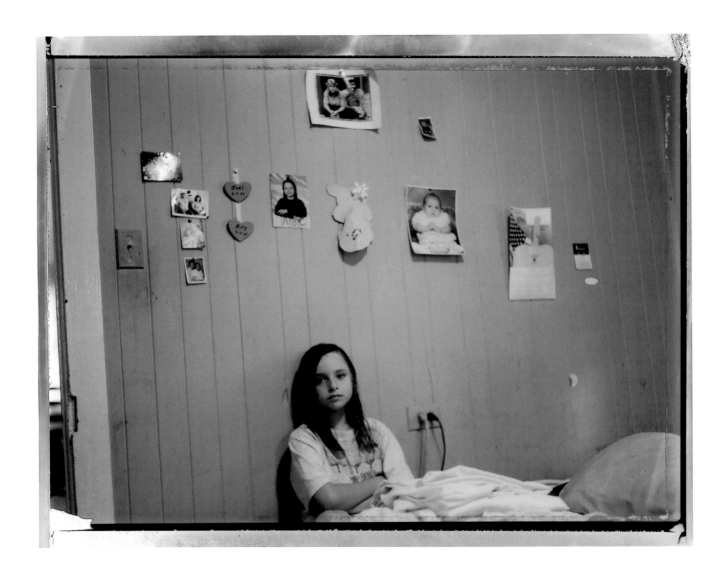

Tasha in the bedroom she shares with Lois ○ 1996

I saw Thomas years ago, but I never met him then. I just
saw him in that truck, working on the same job with
me and Joe. I was like, Joe, why don't you make friends?
But he didn't. I never talked to him.

It was like two years later, three years later, and he came in
the store where I was working one day. It was like a couple of
months later before I started talking to him, and then we
just talked a lot—talked on the phone—for a while. I liked him
too much for anything else. Thomas is a good person.

I think it was just fate for me and him to be together. —TINA

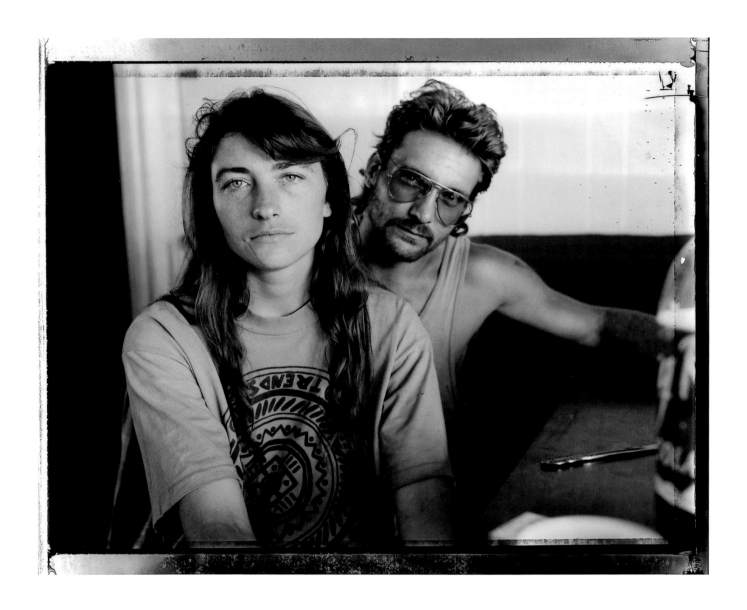

Tina and Thomas ○ 1997

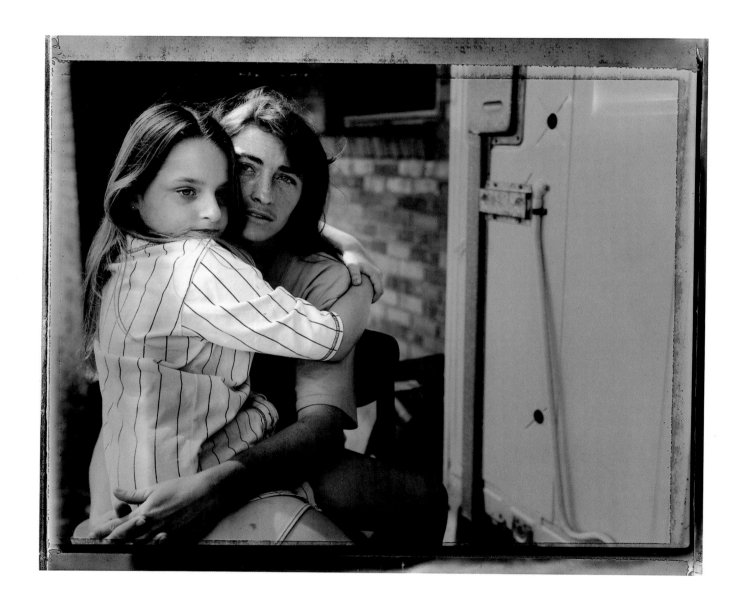

Tasha and Tina ○ 1997

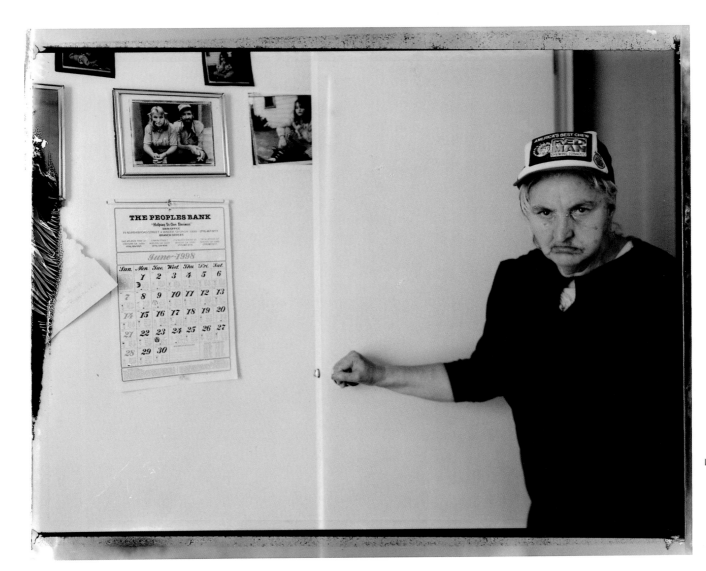

Lois ○ 1998

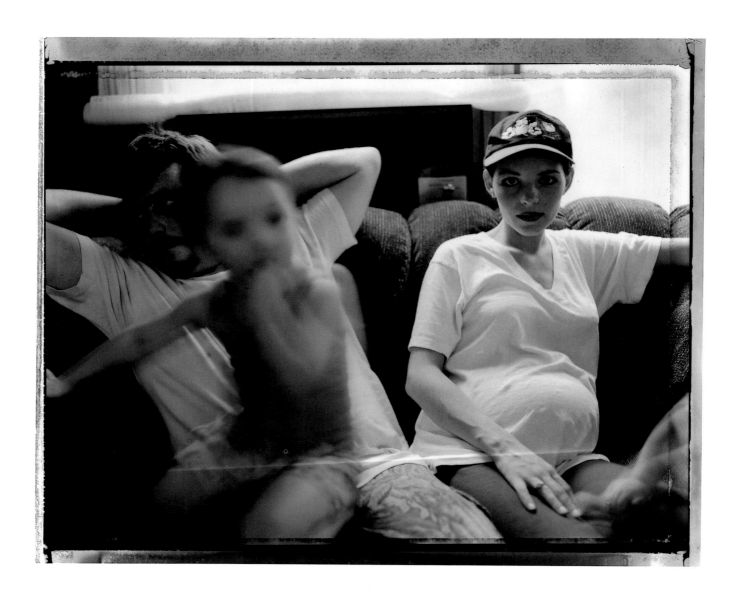

Shane, Christin, and Angela ∘ 1997

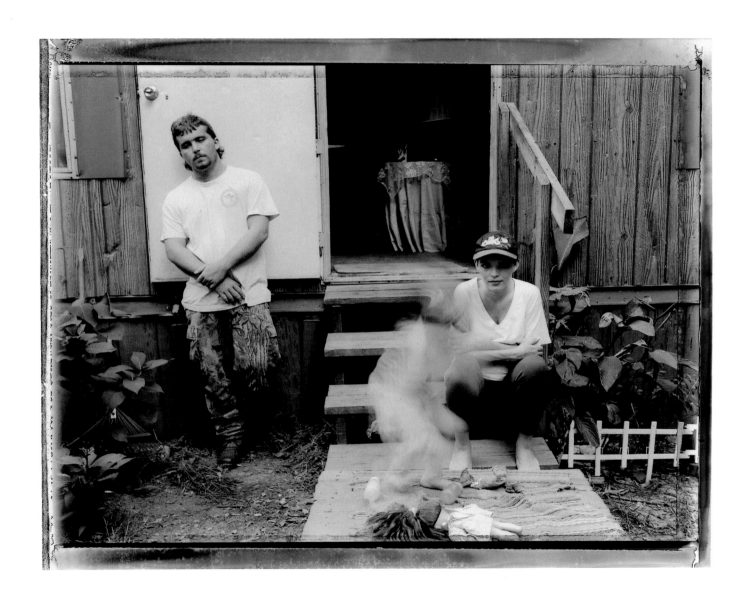

Shane and Angela with Christin ○ 1997

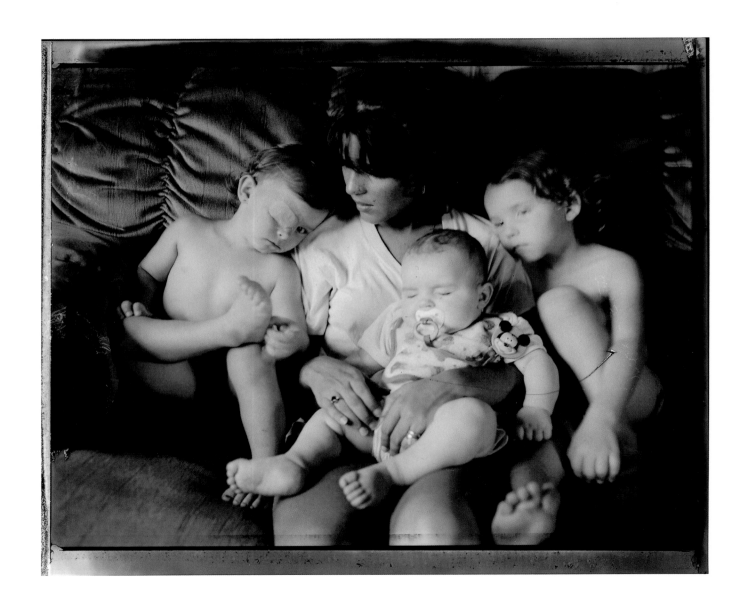

Angela with Christin, Jonathon, and Chellsey ∘ 1998

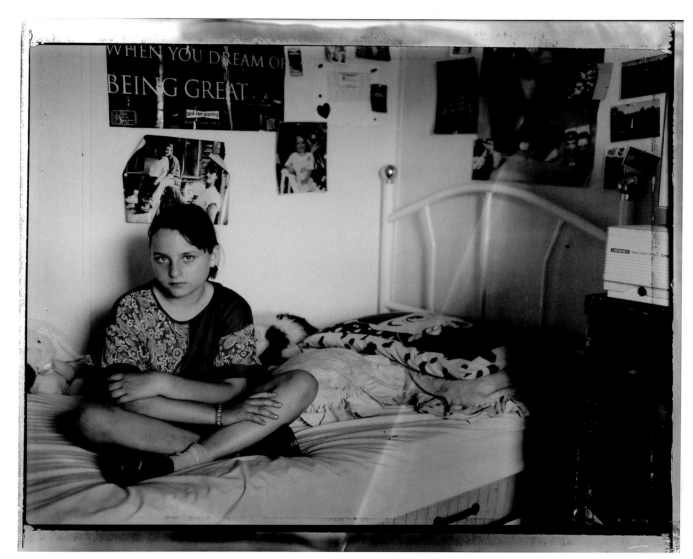

Tasha ○ 1998

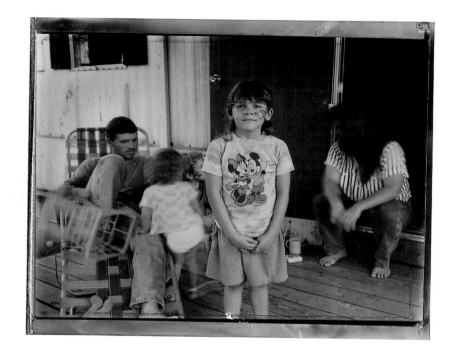

Joe, Lisa, Jessie, Leigha, and Beth ∘ 1998

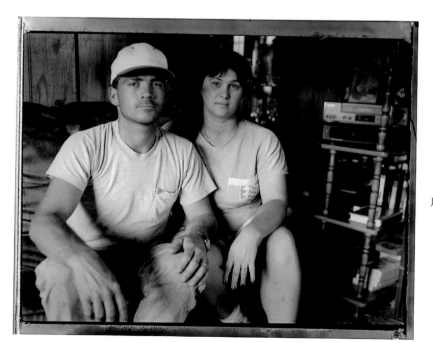

Joe and Beth ∘ 1998

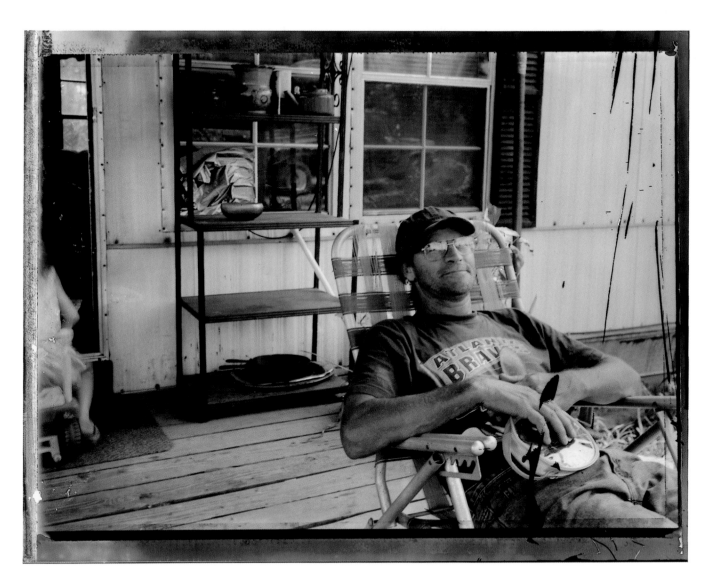

Mickey ∘ 1998

I don't regret getting married. I really don't. I love him. I respect him, and I trust him. And if you don't trust and respect somebody, you can't live with them. But I mean, there's a lot of men in the world who's not like that... Well, the good thing about it is that I didn't have to get married and we had our time together to get to know each other.

Nichole wasn't born for two years. But we had that time together. It wasn't all smooth sailing. We had our ups and downs like everybody else. And we still have our little ups and downs. But if you love each other you can work through it. But, like, I've never cheated on him. He's never cheated on me. We don't believe in all that stuff. Once you get married you're supposed to stay married. Unless it's just absolutely, I mean... And God knows, I have all my faults. And he puts up with all mine just like I put up with his. I tell him I can't come from my family and not be a little crazy.

But watching everybody else I kind of learn what not to do. I mean, a lot of people just give up too easy. You know, you get in a little ol' fight, "Well, I don't like him anymore and I'm just going to go back home," and blah, blah, blah. He used to do that to me all the time when we first got married. He'd get mad and throw his clothes in a bag and go home to Mommy—just maybe be gone two or three hours and come right back. I'd say, "I thought you left!" I'd be mean to him for a day or two, but he never really wanted to go; he just wanted to make me mad. He always wanted to get me to apologize first is what it was. Me, being the stubborn self that I am... It is kind of funny, I mean, in a way.

I think changing jobs really helped, because he worked with his family, and he didn't make much money, and he never was going to when he worked for them. And then he went to work for Jerry and he made like almost twice what he was making. And he got to where he liked it. And then he went to work for Joe, so now he works for Joe. He's a lot better. He's got a lot better attitude. I mean, now when he comes home at the end of the day he's not all tired and ill and mad at somebody.

He talks to me, but I think I'm just about the only one that he does talk to. We'll go see his mama or his sister, and he'll just sit there. He'll tell them, "Hello, how've you been?" and he'll just sit there the rest of the time. Then we're getting up leaving and he'll say, "Well, bye. I love you. I'll see ya later." But like we went Sunday over to his mama and sister's house, and his sister asked him, says, "What are y'all doing? Just out riding around seeing people?" And he said, "Lynn is. I'm carrying her. She's going to see people." Like he wasn't there. I said we both came to visit. So he's got a really nice sense of humor, and he's really, really—he had a real hard life himself.

His mother drank and his father ran around and all this stuff. She just divorced him. I think his parents got divorced when he was five. So it's like basically we want the same things out of life. We want to raise our children without all this adultery and alcoholism and fussing and fighting all the time. You know, nobody gets along all the time, but for the most part we do. We kind of agree on just about on everything, so basically we have the same point of view. —LYNN

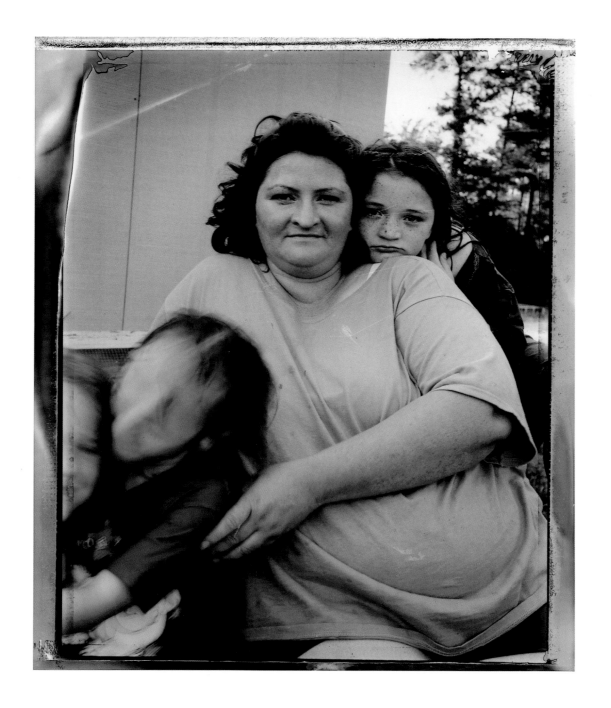

Lynn, pregnant with twins, and Nichole ∘ 1998

VAUGHN: Yesterday you told me that you think something is missing from the book. What is it that's—

MARY: Daddy and Mama both on the front cover—so we're back starting at the beginning, but I feel like Daddy and Mama should both be on the cover.

I'm just a private person. I don't know how it'd make Mama and Daddy feel either. It seems to be so much negative stuff about being poor and poverty and all that. There's a lot of good stuff, too. I mean, a lot. I mean, especially a lot of good stuff that Daddy and Mama done, and the way they worked. Mama's spells, like, wouldn't be all the time. They were just every once in a while when I was little. She was a good mama, and cooked and everything else. Just every once in a while... It talks so much about how Lynn took... Like, for instance, Lynn was taking care of the family being that young. That was just every once in a while. It wasn't like that all the time. Daddy wasn't off drinking and staying out all night most of the time either. That was just every once in a while. And it doesn't make it seem like it's every once in a while. In the book, it makes it seem like it's all the time. That's not the way it was.

And there's one part in there about Lisa, it's talking about a puddle of blood. It wasn't no puddle, it was just a small, little spot where the blood came out. But in the book it makes it seem like she was laying in a puddle of blood. As a matter of fact, I think it uses that word puddle. But it wasn't a puddle of blood; it was just a small amount that had come out of the nose.

VAUGHN: I think that was your comment; I think that was you who said it?

MARY: Yeah, it probably was me talking about Lisa.

VAUGHN: Probably it was your perception as a child, when you were a child it felt like that because it was so frightening.

MARY: Yeah. But it wasn't. But it makes it like she might have her whole body in it or something when it was just maybe a spot as big as one of your sunglass lenses. Of course, it was a six-week-old baby...

And something else with Daddy. There was times when he would take us fishing, and we went swimming a lot, and family things, you know, and then go to visit relatives on the weekends, you know—just all kinds of good stuff that we all did. But it wasn't about being poor; it was just, it was just... We had what we needed. And I think they done real good. Especially with what they had to work with; having all of us it probably drove both of them crazy, I guess. But you think about it, Mama and Daddy had to raise seven young'uns and had to worry about all this, and I've got a one. And him being a teenager— that taught me a lot. I mean, watching him grow up taught me a lot, with him leaving home. Now I can imagine what my mama and daddy felt, too, when me and Jerry started leaving home... and Mickey. But... I mean Alice... Then they had three little ones again. But even though we weren't there, I'm sure they worried about us. We drove 'em crazy. I mean, we did. To have two that died, if that wasn't enough to make him drink more and make her nerves worse. Then to have all us and worry about more coming in, more being born, but worrying about them dying, too. And that always bothered me. I was so afraid that... Tina and Joe, that something would happen to them and they'd die like little Joe and Lisa.

VAUGHN: What's your worry about what people will think looking at this the way it is now? That they won't see the good parts?

MARY: Right. That they're just going to see the negative stuff and hear about the craziness, which is life, but, yeah, I'd like it to be known that we're just regular people, too.

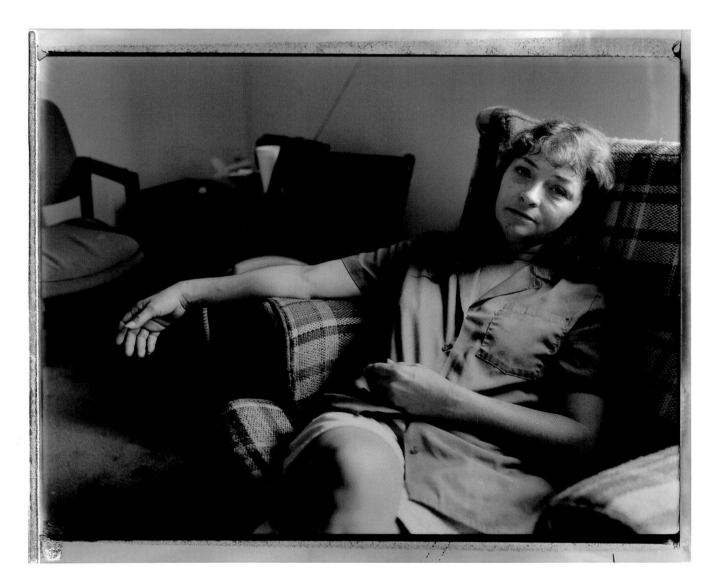

Mary ○ 1998

Tasha ○ 1998

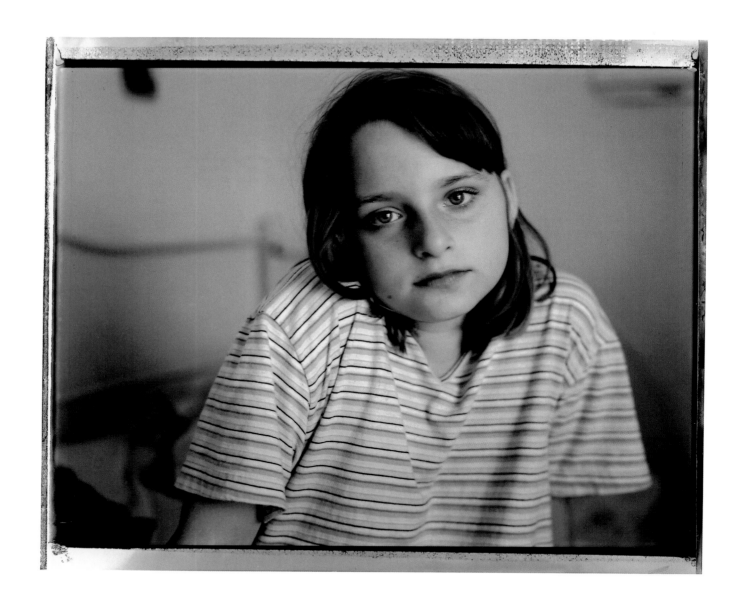

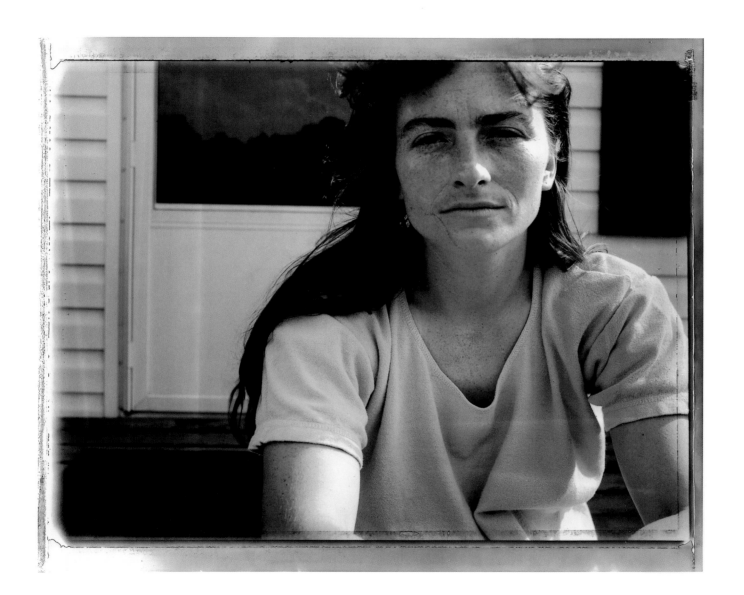

Tina ○ 1998

Everybody took it really hard, but Tina took it the worst. Because she lived with her. And like Tina got to where she didn't want to eat and she didn't want to sleep, she didn't want to talk to anybody, and she'd be real, real quiet, just wanted to be by herself. And then she kinda gradually come out of it.

Midway Christian Church Cemetery ○ 1999

They had already... her and Thomas had already planned to get married in April. They had cancelled it and was not gonna get married because Mama died. And we all talked to her. We told her Mama would still want them to get married and be a family. So they talked it over, and she finally said okay, and they finally went ahead and got married.

April 10th... at the cemetery, at Mama and Daddy's grave instead of inside the church, because she wanted Mama to be there. And Alice took the flowers from her funeral and made it into the bridesmaids' flowers that we carried. None of the bridesmaids wore shoes, I mean, we went barefoot, and I thought that was kinda cool. I was the maid of honor, and Mitchell was the best man, and then everybody in the family was in it; all the sisters and all the brothers and Thomas's brother and stepfather were in it on his side, and Tina's best friend Tina on our side. And all the bridesmaids wore pink. We wore different shades of pink; we were ranging from almost a hot pink rose, to a light pink pink. It was outside by the grave. Tasha was the flower girl and she stood in the middle, and she wore a little short white really pretty lacy dress. Our uncle married her.

It was nice; it was real warm and pretty. It wasn't rainy. It was pretty. —LYNN

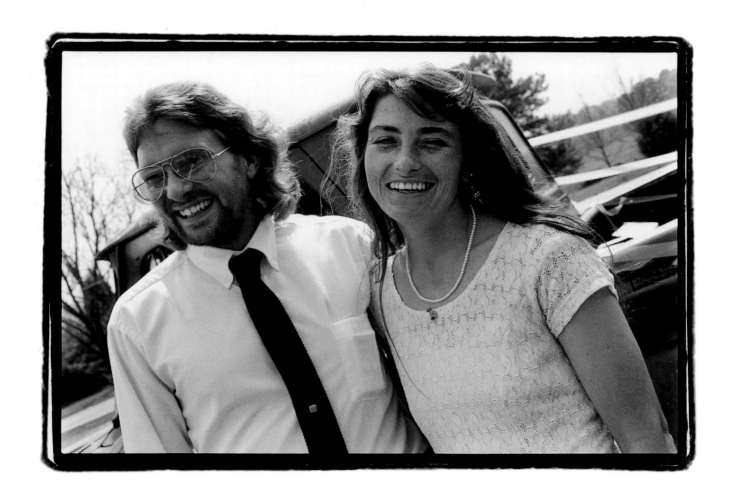

Thomas and Tina ○ 1999

Just Married ∘ 1999

Vaughn Sills has exhibited her work nationally and has been awarded grants by The Commonwealth of Massachusetts Council on the Arts and Humanities and Polaroid Foundation through the New England Foundation for the Arts. Having grown up in Quebec, New England, and the South, she now lives in Massachusetts and teaches photography at Simmons College in Boston. The early photographs in *One Family* were taken with 120mm film; nearly all of the pictures taken since 1982 were made with Polaroid film.